SIGNAL:02

SIGNAL:02

Signal:02 edited by Alec Dunn and Josh MacPhee
© 2012 PM Press
Individual copyright retained by the respective contributors.

ISBN: 978-1-60486-298-0
LCCN: 2010916480

PM Press
PO Box 23912
Oakland, CA 94623
www.pmpress.org

Design by Alec Dunn and Josh MacPhee/Justseeds.org
Cover illustration by Rode Mor
Cover design by Alec Dunn and Josh MacPhee
Frontispiece photo from Portugal, 1970s

Printed in the United States.

Thanks to everyone who worked on this issue, and their patience with the tardiness of the editors. Special thanks to the Kate Sharpley Library, Narita Keisuke from CIRA Japan, and Adrienne Hurley.

SIGNAL is an idea

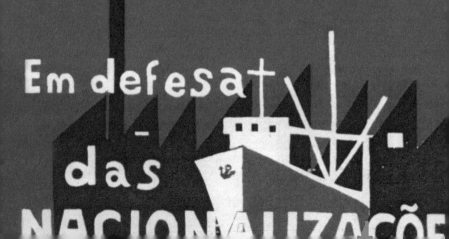

Em defesa
das
NACIONALIZAÇÕE

in motion.

There is no question that art, design, graphics, and culture all play an influential role in maintaining gross inequality. They have also been important tools for every social movement that has attempted to challenge the status quo. But not all tools are the same: we don't use a nail gun to plant a garden, or a rake to fix the plumbing. A healthy and hearty examination on the usage of culture to foster social transformation can give us insight into how these instruments have been used, both as intended and unexpectedly.

Signal aims to broaden the visual discussion of possibility. Social movements have successfully employed everything from print-making to song, theatre to mural painting, graffiti to sculpture. This entire range of expression and its implications for both art and politics are open for exploration. We are internationalists. We are curious about the different graphic traditions and visual languages that exist throughout the world. We feel that broadening our cultural landscape will strengthen the struggle for equality and justice.

The production of art and culture does not happen in a vacuum; it is not a neutral process. We don't ask the question of whether culture should be instrumentalized toward political goals, the economic and social conditions we exist under attempt to marshal all material culture toward the maintenance of the way things are. At the same time, cultural production can also challenge capitalism, statecraft, patriarchy, and all the systems used to produce disparity. With *Signal*, we aspire to understand the complex ways that socially engaged cultural production affects us, our communities, our struggles, and our globe…

We welcome the submission of writing and visual cultural production for future issues. We are particularly interested in looking at the intersection of art and politics internationally, and assessments of how this intersection has functioned at various historical and geographical moments.

Signal can be reached at: editors@s1gnal.org

MALANGATANA'S FIRE

Judy Seidman

"If imperialist domination has the vital need to practice cultural oppression, national liberation is necessarily an act of culture."
 —Amílcar Cabral, 1970

Flags across Mozambique flew at half-mast for two days in mourning when artist Malangatana Valente Nguenha died in January 2011. At his funeral, speakers declared that he was "much more than an artist—he is a part of us," naming him a hero and a freedom fighter. The government originally proposed placing his remains in the Heroes' Mausoleum with postcolonial Mozambique's founders, Samora Machel and Eduardo Mondlane. But in line with his own wishes, Malangatana was buried in his rural home town of Matalana, some thirty kilometers north of Maputo.

In a similar spirit, we need to place his life's work as an artist within the context of building revolutionary culture and national liberation for and with his people. As a painter, poet, musician, intellectual, and revolutionary, Malangatana gave voice to the struggles of the people of Mozambique, and indeed of Africa—in pain and trauma, in joy and victory, in line, color, and beauty. He himself wrote,

Art for me is a collective expression that comes from the uses and customs of the people and leads to their social, mental, cultural and political evolution. Art is a musical instrument full of messages. These are messages that the artist selects to put together in front of humanity.[1]

Brought Up in the Culture of the People

Malangatana was born to a poor family in Matalana in 1936. As a child he herded animals for farmers, which meant that he provided child labor for the owner of the beasts. His was not a romantic carefree childhood spent wandering in the fields while watching over his family's wealth. His father was mostly absent, working in the mines in South Africa. His mother worked as a traditional healer, teeth sharpener, and tattooist. (These were skilled crafts in the Ronga community—the Ronga form one of the three major "tribal" groups of Southern Mozambique.) He learned from two of his uncles who were traditional healers. He absorbed the rich symbols and narratives of rural life from those around him. "Aside from making useful things like gourds, people carved things for witch doctors, and there were very strong, impulsive dances. And there was poetry," Malangatana recalled. "As children, my friends and I, we were already prepared to be poets, dancers, writers, even philosophers, but most important we were full of imagination."[2]

His childhood fascination with his mother's work echoes in the teeth and claws that fill his mature art. That he adapted and built upon this imagery reflects in the title of a painting from the 1960s, "The mouth of society has sharpened teeth; the only way to destroy a monster is to pull out his teeth."

At age nine, Malangatana attended a Swiss mission school. Over his existing rich mix of culture he learned Christianity's myths and traditions. In addition, the mission school taught creative skills like pottery, wood-carving, and basketry. The Portuguese regime closed down the school after he had been there only

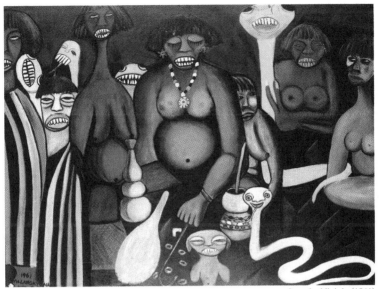

Cena da Adivinha (1961)

two years. By age twelve, he left home to find work in the capital city of Lorenzo Marques (its name was changed to Maputo after liberation).

Art in the Liberation Struggle

Like all the young children who grew up with me in the 1940s I saw many things—many things which made my life political from the start. I saw my parents forced to work on the railway without food. I saw my aunts and my uncles being punished by the *sipiao*, the colonial police. I saw my cousins beaten with the *palmatória*. All this was preparation for a political life. Of course sometimes you don't care what you see. But I cared and feel it still today.[3] —Malangatana

In Lorenzo Marques he worked during the day as a "ball boy" at the tennis club, and studied at night. When club member Augusto Cabral, an architect and amateur painter, kindly gave him a pair of sandals, Malangatana responded by asking for painting lessons. Later he worked as a waiter at the Club de Lorenzo Marques,

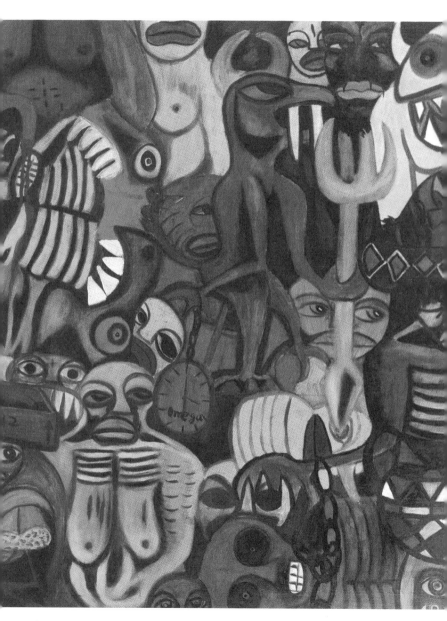

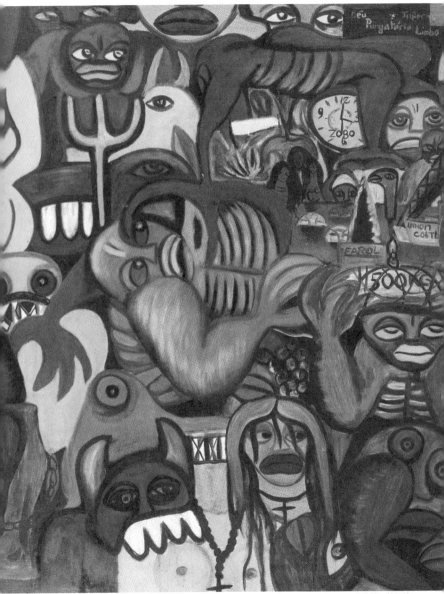

O Feitiço (1962)

and in his spare time studied art with Portuguese artist Ze Julio. He attended classes and events organized through the Núcleo de Arte da Colónia de Moçambique, an association of artists whose aim was to promote art in Lorenzo Marques, and to exchange art between the colony and the Portuguese metropole. He first publically exhibited his paintings in a Núcleo de Arte exhibit in 1959. Leading architect Pancho Guedes became his mentor and patron. Malangatana wrote:

It was here in the capital, in the 1950s, that I began to hear voices of protest against the colonial administration. There were strikes in the docks. . . . In my spare time I was always painting. When I heard about the liberation struggles that were taking place in Tanganyika and Kenya I started painting in protest against the colonial situation. . . . In Mozambique, FRELIMO [Frente de Libertação de Moçambique] was starting to

Cela 4—Expectativa (1967)

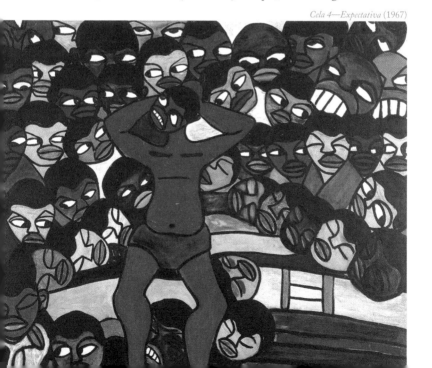

operate in the north of the country. It was a long way from [Lorenzo Marques], but there was no girl or boy here who had not heard of them. At this point I changed from being a landscape or portrait painter to being more the kind of painter I am now.[4]

In 1961, Pancho Guedes introduced the aspiring artist to Eduardo Mondlane (who at that time had been studying in the United States, and visited Mozambique on a UN passport). Malangatana talked about his desire to travel to the United States to become an artist. But Mondlane advised him not to leave Mozambique "because there was a need to develop the arts, and through them to capture the history and suffering of Mozambique's people."[5] In June 1962, a year after visiting Lorenzo Marques, Mondlane launched the revolutionary party FRELIMO in Tanzania.

The young Malangatana took Mondlane's advice to heart. Later, he would argue that art must express the anxieties and aspirations of the people—it should be "a simple dialogue, comprehensible . . . a vibrant thing, crying to the spectator, full of heat and life that makes him cry, or creates tremors in his body."[6] He argued,

It's worthwhile to have art, to make it, to express it as a force of our veins and with the heat of our blood. It ought to be executed with the same passion in which lovers enter in that subconscious relationship at the exact moment of possession. In this manner we look at a statue, a painting, or we read a poem, as if hearing a guitar or an Xitende whose metal wires were forged in the ardent fire burning for centuries in the hearts of the people.[7]

Malangatana saw his artistic passion increasingly driven by the liberation struggle.

He held his first solo exhibit in 1961. The exhibit included the painting *Juizo Final* (Final Judgment), a commentary on the ugliness and savagery of life under Portuguese rule. He commented, "As FRELIMO grew Portuguese people who saw my art said: 'He is abusing our sympathy by being so violent in his painting.' This so-called

'abuse' was my participation in the politics of this country. Then the war came and for the next ten years my painting was dedicated to this struggle."[8]

A common error of critics and art historians in tracing the links between a artist and the liberation struggle is to attempt to pinpoint a date where the artist admits he "joined" the movement. A person living underground and working with the national struggle is highly unlikely to declare they are a member of an illegal structure; indeed, she or he usually denies it—to friends and family, to the police, to the public.

National Liberation Is Necessarily an Act of Culture

Let art seek to combine old forms with new content, then giving rise to new form. Let painting, writing literature, theatre and artistic handicraft be added to the traditional cultivated dance, sculpture and singing.
—Samora Machel[9]

Art historians have also to a large extent neglected the links forged between cultural resistance, pan-African culture, anti-imperialist culture, and Africa's liberation movements. For many decades, progressive art critics and historians have deplored the efforts of imperialist regimes to reject and ignore African cultural histories on the one hand, and to assimilate emergent cultural expression into imperialist discourse on the other. But these same historians have paid little attention to the construction of revolutionary African culture, integrating popular cultural traditions and established forms of expression with demands, experience, and expressions of the national liberation struggle. This gap continues even now, fifty years later, despite the words of key revolutionary leaders such as Eduardo Mondlane, Amílcar Cabral, Marcellino dos Santos, and Samora Machel, who state explicitly that liberation movements emerged from cultural roots. To quote from the poem "Culture" by Samora Machel, FRELIMO leader and president of Mozambique (assassinated in 1986 by the South African regime):

Flauta Mágica (1971)

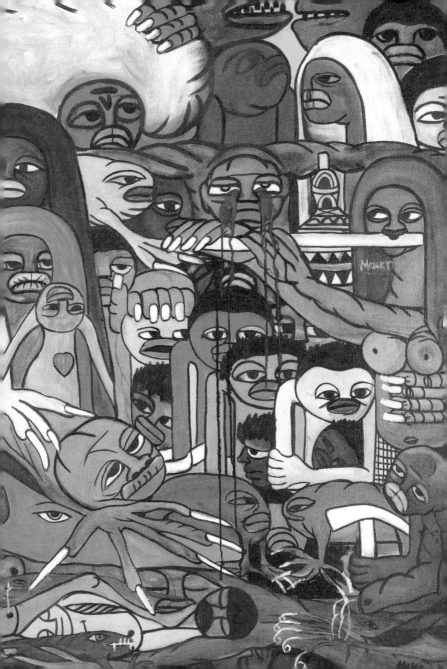

Culture is created by the people,
It's not artists that create it . . .
Look at the peasants
Their music talks of their life
The tilling, the harvesting, the
 watering
He sings of happiness,
He sings and dances,
It might be sad or happy
A reference to history
Or a daily episode.
But that's how it is, it has a real
 meaning,
It defines the enemy
 And how to fight the enemy.

Revolutionary cultural theory specifically refers to Malangatana's artwork. According to Mondlane, "The paintings of Malangatana and José Craveirinha . . . draw their inspiration from the images of traditional sculpture and from African mythology, binding them into works explosive with themes of liberation and the denunciation of cultural violence."[11] We should also note that during the long years of the liberation war (the late 1960s and early '70s), FRELIMO supported artists' collectives that made Makonde sculpture in the "liberated zones" of northern Mozambique and in Tanzania. Like Malangatana's images, the symbols and metaphors used in these sculptures were not a reworking of traditional, primitive, or supernatural themes, but a conscious use of the popular aesthetic to address the experience of struggle:

FRELIMO mobilisers not only set up carving collectives, they also influenced the subject matter of the carvings. They encouraged carvers to create new themes that would illustrate the evils of colonial oppression and the carvers responded by developing a "genre" of "personages in a state of oppression." Among the themes included in this genre was the figure of the suffering woman with head in hand, the African carrying the European, the woman shielding her head from the attacks of a policeman, and the tied-up African being led away by a policeman. In addition to the personages in a state of oppression, satirical and subversive images were also carved. For example the carver Nanelo Mtamanu stated that during the armed struggle members of the Beira co-operative used to make, among other themes, images of President Caetano and of the one-eyed Luis de Camoes. These carvings were undoubtedly

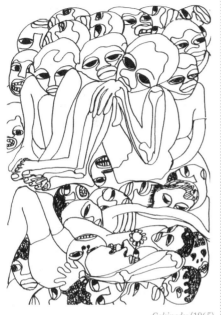

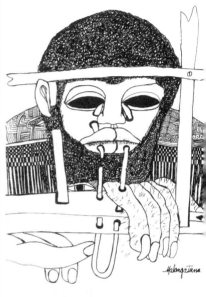

Calcinados (1965)

Cela Disciplinar (1969)

caricatures of the formal bust portraits that Portuguese patrons had previously commissioned from Makonde carvers. According to Mondlane . . . some Makonde carvers, who had experience of carving religious images, expressed their rejection of the colonial culture by creating works that subverted those same religious themes.[12]

In this political, social, and cultural context, Malangatana pursued his artistic career in Lorenzo Marques. In 1964, he exhibited paintings in a collective show of new Mozambican artists. The Portuguese secret police (PIDE) shut down the exhibition, as part of a broader crackdown on intellectuals supporting the struggle. Malangatana spent eighteen months in the Central Jail of Machava, along with other leading cultural figures such as writer Luis Bernardo Honwana, and poets José Craveirinha and Rui Nogar. Malangatana shared a prison cell with Craveirinha.

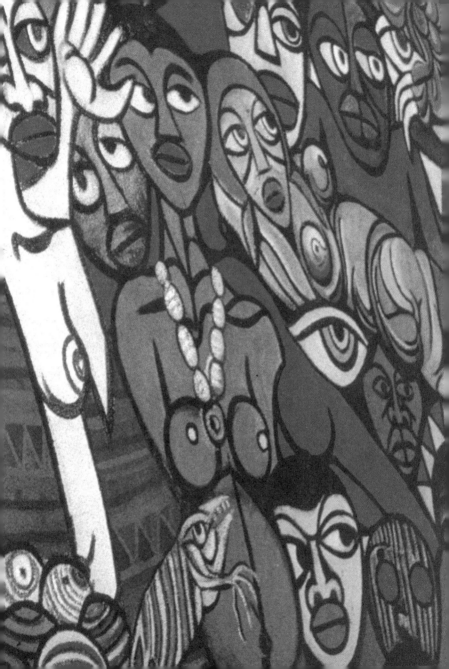

When PIDE failed to prove Malangatana's FRELIMO connections, they released him uncharged. He continued to paint.

The armed struggle in Portugal's African colonies played a major role in the Carnation Revolution that overthrew the Portuguese dictatorship in April 1974. In June 1974, Malangatana returned home to welcome Mozambique's independence, and to join the newly formed FRELIMO government. He spent four years working for the government, first as a city official in Maputo (the post-revolution renaming of Lorenzo Marques), then in the Ministry of Cultural Affairs. Later, he served as a FRELIMO deputy in Parliament. During these years he produced art for political mobilization, for events, and for literacy campaigns. However, Malangatana maintained that even during this period his artwork did not aim at promoting political points, "I am a social painter, but not in a pamphleteering way."

An outpouring of artistic expression occurred in the decade after independence, with painting on public walls: the murals of Maputo. In the first years after 1974, people painted slogans, political images, and revolutionary graffiti. In 1982, Albie Sachs—a former political prisoner for his role in the South African liberation struggle, living in Mozambique—wrote: "In a wave of enthusiasm to express what had been denied and affirm what had seemed reachable only in fantasy, thousands of Mozambicans in every part of the country got out their paint pots and emblazoned the walls." By the end of the 1970s, this spontaneous outburst became more structured, more formalized, with murals designed and executed by experienced muralists and artists, working individually and collectively. Mural collectives were structured by refugees who had developed their skills working with the Popular Unity cultural movement in Chile.

The People's Struggle in the Context of Nature (late 1970s)

Malangatana collaborated on a mural at the Ministry of Agriculture, started by Chilean veteran Moira Toha and a team of mostly Chilean volunteers. Albie Sachs described Malangatana's input to the mural as

introducing his own intense, anguished and highly personal style into the painting, added drama and tension . . . It was paradoxical to see joyous fruit and footballs and flying fish coming from the brush of the Chilean exile, whose brother-in-law had been hanged by the fascists, while sad and uncertain faces emerged from the strokes of the Mozambican, a jolly person living in his own free and independent country.

Sachs describes the result as a statement that "optimism is not self-realising, that the victory of the revolution creates only the conditions for happiness, not happiness itself."

Malangatana was also commissioned to paint a mural in the Natural History Museum in Maputo. Sachs, again:

This is a giant impetuous dream of colour and symbol crowding the three walls. The lines move but the people are still trapped in the commotion swirling around them, asking questions of the viewer, looking uncertainly at the world which is changing all around them, wondering about their ancestors, about faith, about the revolution. The colours may dance, there may be movement, vitality, brilliance in the scene, the garden of humanity may be vibrant. But the people are silent, and their eyes are sad. Though life may be rich and full and variegated, there is no easy pathway to happiness, no simple exit from suffering: we must go gently with the people since they have suffered.

Two Steps Back: Confronting the Violence of Counter-Revolution

By 1981, Malangatana had returned to painting full-time. But again the situation was changing. From the time of FRELIMO's victory, neighboring white racist regimes in Rhodesia and South Africa sponsored counter-revolutionary armed bands, called RENAMO, to destabilize liberated Mozambique. Malangatana remarked, "For a

brief period after independence my painting became softer. I was using more blues, yellows, whites. Then the liberation war in Zimbabwe started and RENAMO was set up by the Rhodesians. And when that war was over, South Africa took over backing RENAMO— destroying more than the Portuguese ever destroyed."

Malangatana's brother and other family members were murdered by RENAMO. This time, from 1981 to 1994, has been called Malangatana's blue period. His paintings say, "a luta continua," we have won one step but the terror is not over. He stated, "My painting got more violent, more shocking, with reds that were stronger than ever," he commented. "To see the schools, the hospitals, the farms, the railways—all symbols of hope and growth for our country being destroyed. To see pregnant women, children, men being killed—sometimes two or three hundred in one day, in forty minutes—creates in my heart a sadness that does not stop."

He threw his energy and his art into calling for peace,

an end to violence. He helped found the Mozambican Peace Movement. He worked as a negotiator to end the sixteen-year civil war, and ultimately was a signatory to the 1992 peace accord between FRELIMO and RENAMO.

Throughout the 1990s, Malangatana worked to build Mozambique's new national culture. He helped to establish the Mozambique National Museum of Art and the Centre for Cultural Studies. He helped relaunch the Núcleo de Arte cooperative. He founded a cultural project in his hometown of Matalana, integrating creative artwork with historical and traditional cultural collections and their preservation. He began a youth programme on the outskirts of Maputo. In 1997 UNESCO appointed Malangatana as their Artist for Peace. He responded that the honor was not his alone but must be "bestowed on mothers, on children, on all those who are suffering."

In the last decade of his life, Malangatana spoke and exhibited across the world, becoming Mozambique's

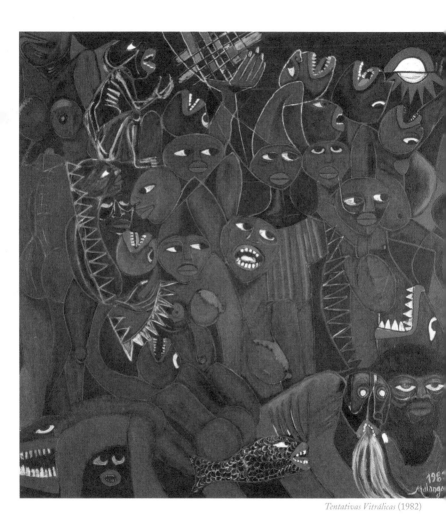

Tentativas Vitrálicas (1982)

cultural ambassador. In 2006, Mozambican president Guebuza awarded him the "Eduardo Mondlane Order" for contributions during colonial rule, for his role as an instrument of political intervention, and for mobilization among the people. Yet above all, he remained a people's artist. *Guardian* journalist Duncan Campbell describes meeting Malangatana in 2005: "What was remarkable about him was that he brushed off questions about his own work and insisted instead on taking us on a magical conducted tour of local artists from painter to sculptor to batik-maker. He was anxious that they should receive publicity rather than him. For their part, they clearly held him in high esteem. 'He is my general,' one of the young artists told me."

And Malangatana said of his own work:

The lines are more human now. They are laughing. Instead of chains there are tattoos—symbols of culture. The lines are very thick, very open. Something around me is guiding me to work like this. Something is really changing. We are being influenced by a positive fire. A fire that is burning under our feet, warming us.

Sem título (1998)

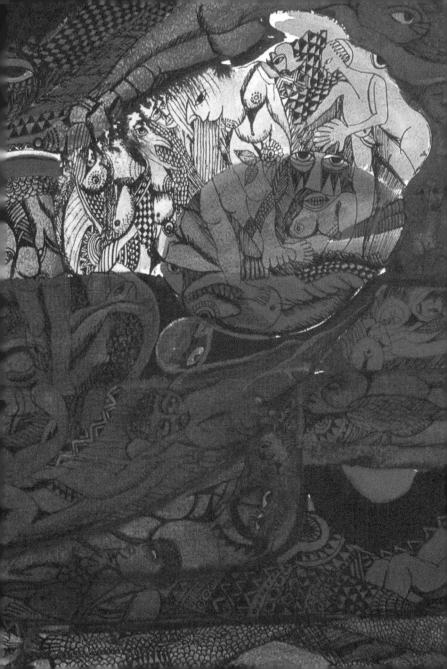

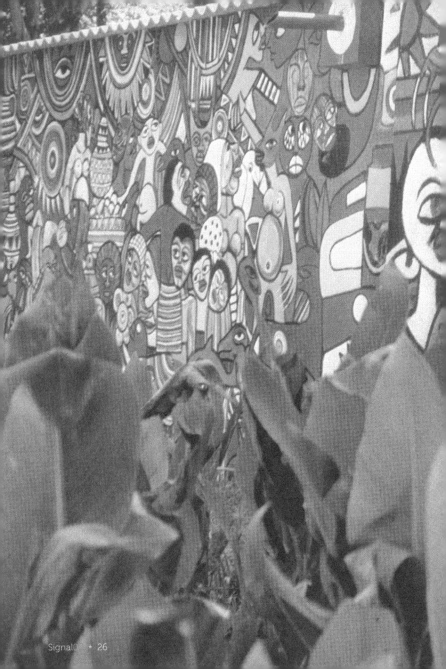

Notes

1. http://allafrica.com/stories/201101060173.html.
2. Quoted in http://howweliveinsilence.blogspot.com/2011/01/in-memoriam-malangatana-great-artist.html.
3. Malangatana, "Positive Fire," *New Internationalist* 192 (February 1989), http://www.newint.org/features/1989/02/05/fire/.
4. Ibid.
5. This incident has been described in an interview with Benedito Machava after Malangatana's funeral.
6. Betty Schneider, "Malangatana of Mozambique," *African Arts* 5 no. 2 (Winter 1972), 40–45, http://www.jstor.org/stable/3334671.
7. Ibid.
8. Malangatana, "Positive Fire."
9. Cited in E. Alpers, "Representation and Historical Consciousness in the Art of Modern Mozambique," *Canadian Journal of African Studies* 22 no. 1 (1988), http://www.jstor.org/pss/485491.
10. Excerpts from: Samora Machel, "Culture," in Chris Searle, *Words Unchained: Language and Revolution in Grenada*, (London: ZED Books, 1984), 2.
11. Berit Sahlstrom, *Political Posters in Ethiopia and Mozambique* (Stockholm and Uppsala: Almqvist & Wiksell, 1990), 9.
12. Zachary Kingdon, *A Host of Devils: The History and Context of the Making of Makonde Spirit Sculpture* (London and New York: Routledge Harwood Anthropology, 2002), 28.
13. 1992 interview at art opening in Maputo, Jane Perlez, *New York Times*, Oct 24 1992.
14. Albie Sachs, *The Murals of Maputo*, draft manuscript, 1982, 6 (in the author's possession).
15. Ibid.
16. Ibid.
17. Ibid.
18. Malangatana, "Positive Fire."
19. Ibid.
20. Joe Pollitt, "Malangatana Ngwenya Obituary," the *Guardian*, January 17, 2011, http://www.guardian.co.uk/world/2011/jan/17/malangatana-ngwenya-obituary.
21. Malangatana, "Positive Fire."

There is only one significant monograph on Malangatana, which is well worth tracking down: Júlio Navarro, ed., *Malagantana Valente Ngwenya* (Lisboa: Editorial Ndjira, 1998). All images of murals are from the book *Images of a Revolution* published by Zimbabwe Publishing House in 1983.

The People's Struggle in the Context of Nature (late 1970s)

STREET MURALS IN THE
PORTUGUESE
REVOLUTION

>>PHIL MAILER

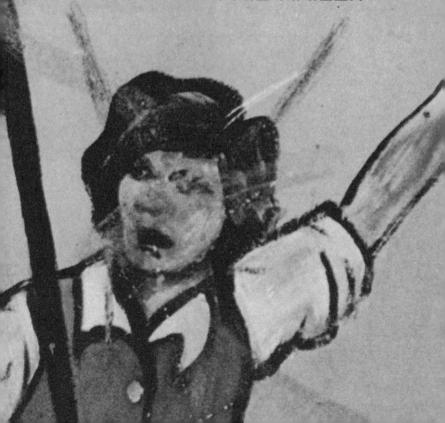

After the military coup in Portugal on April 25, 1974, and the overthrow of almost fifty years of Fascist rule, there followed eighteen months of intense social transformation which challenged almost every aspect of Portuguese society. What started off as a coup transformed into a profound attempt at social change from the bottom up, making daily headlines in the world media.

After the revolution, the streets were taken over by murals, paintings, and stencils—mainly put up by the various political parties. While the Christian and Popular Democrats (right-wing), as well as the Centrist Socialist Party, received ample funding from their sister parties throughout Europe and could afford to print posters—which they duly plastered up all over the country—the Communist Party and the various left-wing groups relied on street murals to get their message across. Portugal was one of the poorest countries in Europe at that time. Agriculture in the south was organized in huge latifundios (ranches) and worked by peasants, while in the north it was divided into tiny holdings in which families eked out a miserable subsistence living. Factory workers were poorly paid and any opposition or union organizing was severely repressed under Fascism. The murals reflected this situation and often showed peasants, workers, and soldiers coming together to oust the big rancher or factory owner. Just about every street, every wall, was covered in these didactic messages, often in brightly colored drawings which covered whole buildings.

After the coup in '74, multiple factions emerged within the Armed Forces Movement (MFA). Some were loyal to General Spínola, who had been part of the old regime but was appointed head of the new Junta. Another faction would emerge later, The

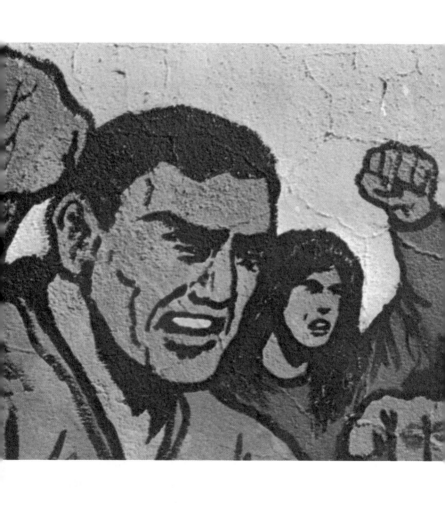

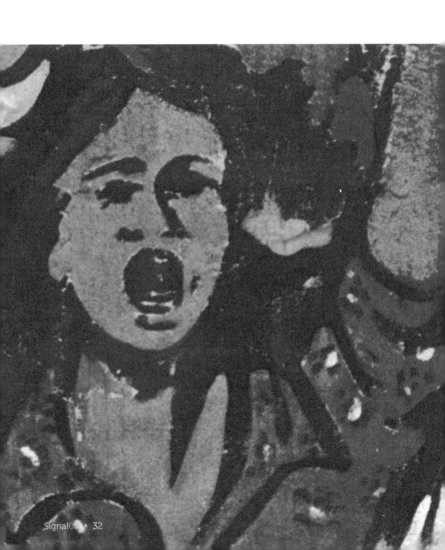

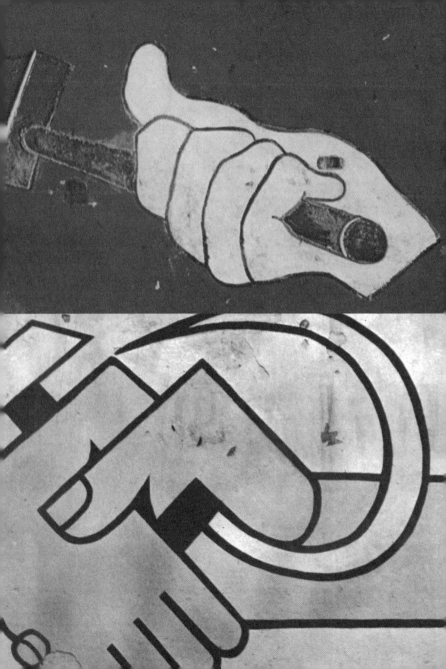

Group of Nine, which supported the centrist Socialist and Popular Democrat parties and would some eighteen months later stage the second coup that brought Portugal back into parliamentary capitalist democracy. But in the early days, after April, it was the autonomous factions within the MFA, as well as those who became Communist Party sympathizers and those who had actually carried out the coup who were in charge. Their main organizational body was called COPCON (Continental Operations Command), led by Otelo Saraiva de Carvalho and aligned with the far left. COPCON became the arbiter for all political disputes, which meant that the ordinary police had been neutralized to a large extent, at least as far as political acts were concerned. One result was that anyone could go out, day or night, with paint cans and paint away to their heart's content, which helped the mural movement to flourish. It was quite a unique popular painting movement, more akin to South America than Europe. The movement started quickly in May '74 and by the summer of '75 there was hardly an unpainted wall anywhere in Lisbon or in the rural towns across the country. Generally political groups respected the murals of others, there was an informal protocol that implied that if a group got to a wall first then they had the right to keep it and rework it.

In the summer of 1975, thousands of "tourists" came from neighboring Spain to see the sheer poetry and color of the murals. I also visited Spain around this time and it was night and day, you crossed the border and there was nothing, just blank walls and the striking contrast between utopian murals and the drab ads for consumer goods that decorated Francoist Spain. Unfortunately Franco was not to die until just five days before the November 25, 1975, right-wing coup which restored Portugal to European parliamentary capitalism.

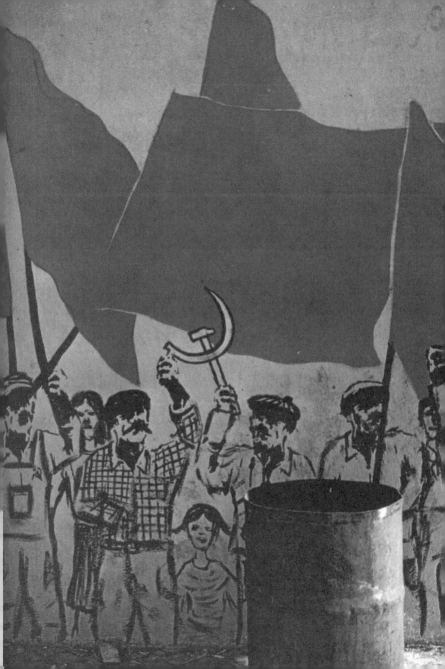

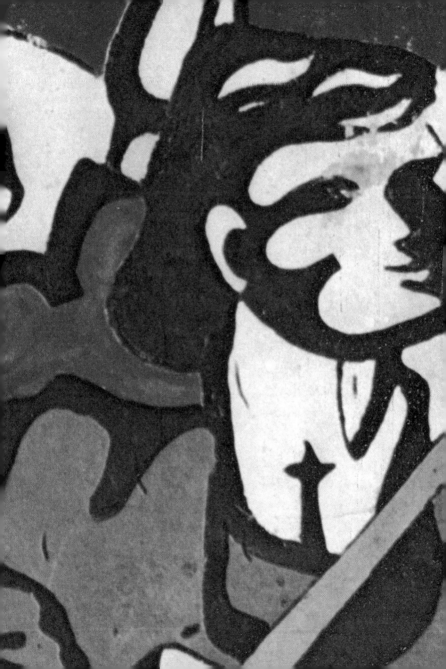

By far the largest number of murals were carried out by militants of the Portuguese Communist Party (PCP) who would often set up ramshackle scaffolding and paint in broad daylight. Popular themes here were the unity of the MFA-POVO (the unity of the leftist Armed Forces Movement and the "People"), as well as support for demonstrations, meetings, and rallies. "The people united shall never be defeated," a popular slogan of the Allende government in Chile was frequently used; "United we will win" was another. But a lot of the murals, while carried out by party militants, expressed an optimistic hope and a genuine desire for class unity rather than support for an actual political party. These were by far the most creative murals. This was especially so in the rural areas of Alentejo, in the South of Portugal, home of the injustices of the latifundio system. The far left and especially the Maoist MRPP were also prolific mural producers. (Strangely, the present European Commission leader, José Manuel Barroso, was one of them!) But here there was a clear

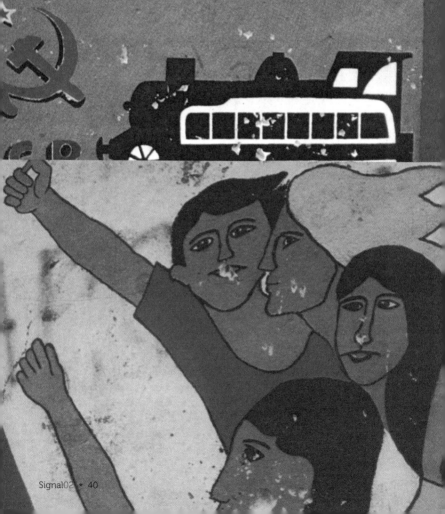

das
NACIONALIZAÇÕES

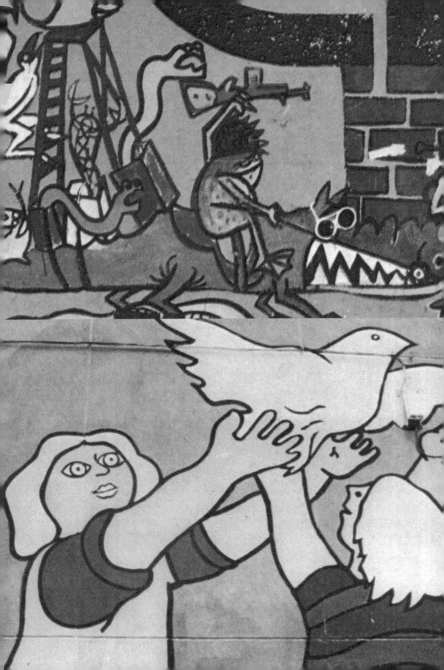

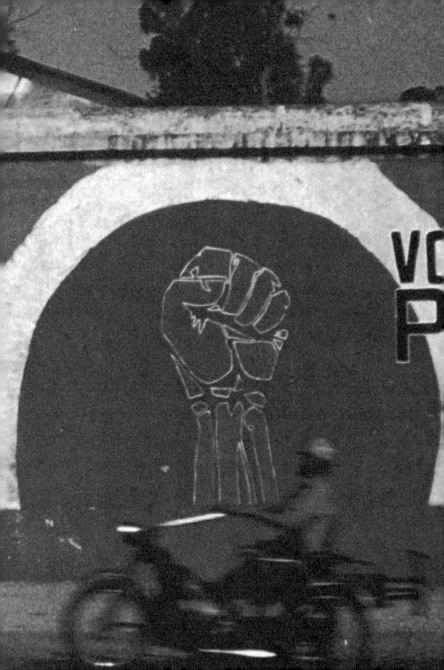

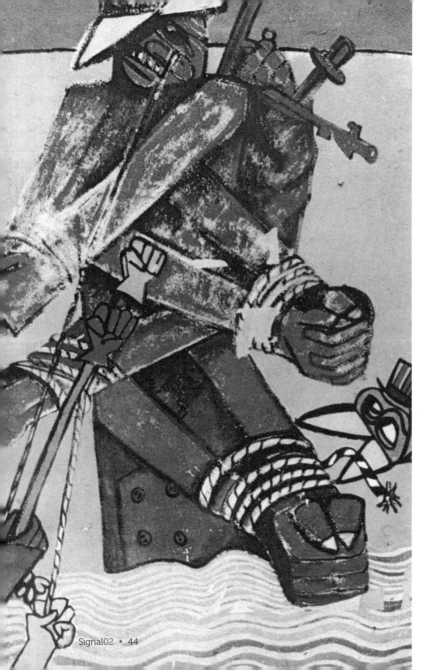

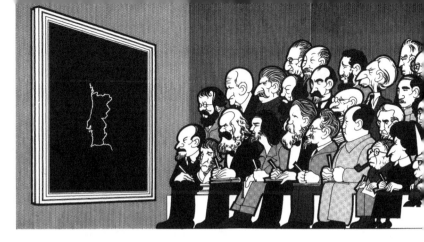

Marxist-Leninist vanguardism in their message, usually with a representative of the Party leading thousands of peasants and workers on the road to salvation. If the blatant ideology was diminutive, the sheer size of their murals was clearly extraordinary, they had taken over various strategic street corners in Lisbon and there was no ignoring them. Even the most ignorant of tourists couldn't help but see. Others on the far left, the UDP and MES, in particular, were also prolific; their images were positive and stressed the unity of factory and farm workers and ordinary soldiers, referring to them frequently as "The Sons of the People."

Of course these murals didn't stand alone. They existed side by side with the "Dynamisation Campaign" of the MFA, organized through COPCON, which hired professional artists like João Abel Manta to produce some excellent posters, like the now-famous MFA-POVO poster, or the poster of a group of intellectuals looking at a map of Portugal trying to figure out was going on, as well as the enigmatic and surreal poster "Poetry Has Hit the Streets."

While political parties did use paid professional artists, most of the wall murals were spontaneously done by ordinary workers and militants whose hearts and minds were focused on their own revolutions, in which they were passionately involved in their daily lives. There was a certain refreshing naivety (both political and aesthetic) in them, a belief in the revolutionary process and an overall optimism toward class struggle. Unfortunately many of these "political" murals

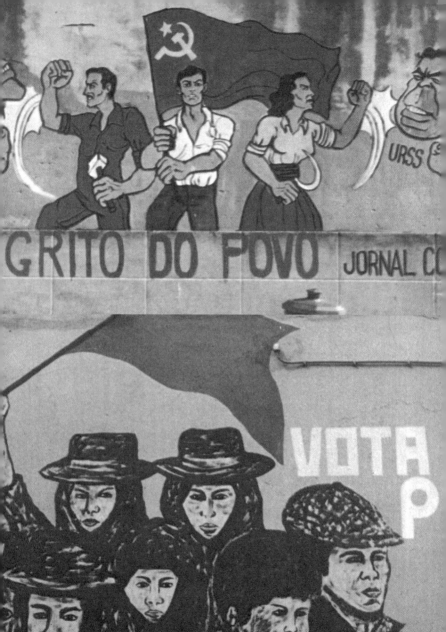

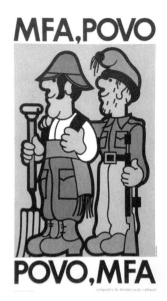

MFA, POVO

POVO, MFA

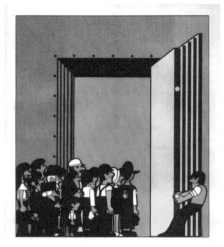

OS TRABALHADORES DA NOVA BANCA
ABREM AO POVO A PORTA DO FUTURO

SINDICATOS BANCARIOS DE COIMBRA, LISBOA E PORTO ■ MFA • DINAMIZAÇÃO CULTURAL • ACÇÃO CÍVICA

lacked both imagination and humor. The messages were ideological to the extreme, with a complete lack of irony, just giant but bland statements and aspirations of unity and of successful class struggle. There were exceptions, however. One bright graffitist intervened in the doctrinaire messaging, painting the words "Taxi, Taxi!" in a word bubble coming from the image of Maoist leader Arnaldo Matos as he addressed tens of thousands of workers. It made the whole thing seem ridiculous, a moment of true subversion.

Although they sometimes referenced the posters and graffiti of Paris in 1968, the Portuguese murals were never to achieve that level of imagination, wit, and graphic creativity. Even with these limitations, the Portuguese experience remains one of the greatest, and least explored, mass creative explosions of popular street art and wall murals. ❸

Phil Mailer is the author of *Portugal: The Impossible Revolution?*, a second edition of which was published by PM Press in 2012. All images are taken from the book *As Paredes na Revolução*, edited by Sérgio Guimãras (Mil Dias Editoria, 1978).

FREEDOM

A Journal of Anarchist Communism.

SEPTEMBER, 1908.

SOCIALISM

AND

SOCIAL DEMOCRACY

FETTERS OF FEUDALISM

THE DEATH PENALTY

MONTHLY ONE PENNY

SELLING
FREEDOM

Early Twentieth-Century
Anarchist Broadsides
by Alec Dunn and Josh MacPhee

WHILE HUNTING THROUGH THE PILES AND BOXES AND FILE CABINETS full of anarchist print at the Kate Sharpley Library in Northern California, we unearthed a box of thirty-six letterpressed broadsides advertising *Freedom* newspaper. The broadsides were one hundred years old, on an orange-ish newsprint, folded in quarters and on the verge of disintegration. We decided on the spot not only that we needed to photograph these before they quite literally disappeared but that they would make a great feature in *Signal*.

Freedom: A Journal of Anarchist Communism is an anarchist publication that began in 1886. It was founded by a group of London-based propagandists (notably, Charlotte Wilson and an exiled Peter Kropotkin) with the intention of producing a nonsectarian anarchist monthly newspaper. Freedom Press was launched shortly thereafter and became the primary publisher of anarchist propaganda and ideas in Britain.

Freedom published continuously until 1927. It was revived briefly during the Spanish Civil War to promote solidarity with the social revolution happening there, and then again during World War II. It has been published continuously since, and still maintains a social center in London.

After some initial investigations into the purpose and use of these broadsides, we are largely still in the dark. Our best guess is that these were used as public advertisements for the paper, which

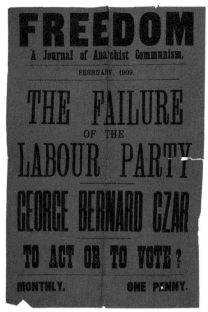

were common in the early twentieth century. They were hung on newsstands or pasted on walls with other advertisements. They might have been used by street vendors hawking the paper and possibly also displayed in the windows of the Freedom Press bookshop. They were printed with hand-set wood type and produced on a different paper from the actual newspaper.

Not only are these amazing examples of turn-of-century printing and letter forms, but they are a fabulous overview of the thoughts and ideas of one wing of the UK anarchist movement for the decade of 1908 through 1917. It is clear that anarchists then were masters of the same hyperbole, grandstanding, and overstatement that is so common in today's movement—the words "bloodthirsty" and "tyranny" pop off the page. Seeing "Our Vanishing Liberties" and "The Peril of Militarism" on these posters is bittersweet. It's terrifying that our larger social situation has changed so little over the last century but also heartening to know that anarchists were on the frontlines of social struggles then, as they are today. ❸

FREEDOM

A Journal of Anarchist Communism.

APRIL, 1909.

FRENCH POSTMEN'S

GREAT VICTORY

FOR

DIRECT ACTION

MODERN MAIDENS' MORALS

MONTHLY ONE PENNY

FREEDOM

A Journal of Anarchist Communism.

JUNE, 1909.

ANARCHISTS
AND THE
SITUATION

SOME SOCIALIST
SIDELIGHTS

INDUSTRIAL UNIONISM

MONTHLY ONE PENNY

FREEDOM

A Journal of Anarchist Communism.

JULY, 1909.

THE
BLOODTHIRSTY
TSAR!
HOW HE GOVERNS
RUSSIA

MONTHLY ONE PENNY

FREEDOM

A Journal of Anarchist Communism.

SEPTEMBER, 1909.

GENERAL STRIKE
IN SWEDEN

IS COMMUNISM
NECESSARY

THE EVOLUTION OF
ANARCHISM

MONTHLY ONE PENNY

FREEDOM

A Journal of Anarchist Communism.

NOVEMBER, 1909.

FRANCISCO
FERRER
AND
HIS SCHOOLS
BY
ONE WHO KNEW HIM

MONTHLY ONE PENNY

FREEDOM

A Journal of Anarchist Communism.

JANUARY, 1910.

ALL GOVERNMENTS ARE ROBBERS

WHY DO YOU ELECT THEM?

MONTHLY — ONE PENNY

FREEDOM

A Journal of Anarchist Communism.

AUGUST, 1910.

THE MESSAGE
OF
ANARCHY

THE SPONTANEOUS
STRIKE

MONTHLY ONE PENNY

FREEDOM

DECEMBER, 1910.

SHALL JAPAN EXECUTE DR. KOTOKU AND 25 OTHER SOCIALISTS AND ANARCHISTS?

MONTHLY - ONE PENNY.

FREEDOM

FEBRUARY, 1911.

D. KOTOKU: HIS LIFE-STORY AND PHOTO.

THE MYLIUS CASE

MONTHLY - ONE PENNY.

FREEDOM

OCTOBER, 1911.

THE TYRANNY OF STOLYPIN.

TRADES UNION CONGRESS.

AN OPEN LETTER TO A SOLDIER.

MONTHLY - ONE PENNY.

FREEDOM

NOVEMBER, 1911.

25TH ANNIVERSARY OF "FREEDOM."

THE GROWTH OF THE ANARCHIST MOVEMENT.

AN OPEN LETTER TO THE B.S.P.

MONTHLY - ONE PENNY.

Freedom

FEBRUARY, 1913.

THE "SLUMP"

IN

STATE SOCIALISM

THE ILLUSION

OF

GOVERNMENT

MONTLY — ONE PENNY.

Freedom

MARCH 1913.

THE PERIL

OF

MILITARISM

THE EDUCATION

OF

THE REBEL.

MONTHLY - ONE PENNY.

Freedom
JULY, 1913.

THE LAND
AND THE
LABOURER
ANARCHISTS
AND
TRADE UNIONS
MONTHLY - ONE PENNY.

Freedom
AUGUST, 1913.

PUNISHMENT
AND
THE LAW.
DESPOTISM
IN
PORTUGAL.
INTERNATIONAL NOTES.
MONTHLY - ONE PENNY.

Freedom
SEPTEMBER, 1913.

THE DECLINE
OF
COERCION
THE CITIZEN
AND
THE PRODUCER
DEATH OF BEBEL
MONTHLY - ONE PENNY.

Freedom
OCTOBER, 1913.

TRADE UNION
CONGRESS
THE CURSE
OF
COMPROMISE.
FERRER AND FORCE.
MONTHLY - ONE PENNY.

Freedom

NOVEMBER, 1913.

THE
STRIKE WEAPON
AND
ITS CRITICS.

A GENERAL VIEW
OF ANARCHISM.

LAND AND LIBERTY.

MONTHLY - ONE PENNY.

Freedom

APRIL, 1914.

GOVEREMENT

IN THE

MELTING POT

COMMUNISM

OR

INDIVIDUALISM

MONOPOLIES

MONTHLY - ONE PENNY.

Freedom

MAY, 1914.

MAY-DAY MESSAGE

ANARCHIST CONGRESS

THE
MODERN STATE

MONTHLY - ONE PENNY.

Freedom

JUNE, 1914.

WHAT IS A REVOLUTION?

MINERS' WAR
IN
COLORADO.

BAKUNIN CENTENARY.

MONTHLY - ONE PENNY.

Signal02 * 64

Freedom

JULY, 1914.

MALATESTA

ON

GENERAL STRIKE

IN ITALY

VOTES AND VIOLENCE

MONTHLY - ONE PENNY.

Freedom

AUGUST, 1914.

THE CRIME OF CRIMES

CAPITALISM CONDEMNED

WHAT WE WANT!

MONTHLY - ONE PENNY.

Freedom

NOVEMBER, 1914.

ANARCHISTS

ON

THE WAR

AND

ANTI-MILITARISM

MONTHLY - ONE PENNY.

Freedom

DECEMBER, 1914.

GOVERNMENT

AND

THE PEOPLE

SHATTERING

THE

DUMB GODS.

CORRESPONDENCE ON THE WAR

MONTHLY - ONE PENNY.

Freedom

APRIL, 1915.

MUZZLING

THE

WORKERS.

WHAT ARE WE FIGHTING FOR?

INTERNATIONAL NOTES.

MONTHLY - ONE PENNY.

Freedom

JULY, 1915.

REACTION

IN

FULL SWING

THE STATE: WHAT IS IT?

MONTHLY - ONE PENNY.

Freedom

OCTOBER, 1915.

RUSSIAN AUTOCRACY AT BAY.

MUNITIONS AND SLAVERY.

MONTHLY - ONE PENNY.

Freedom

DECEMBER, 1915.

WORKERS AND ECONOMY.

OUR VANISHING LIBERTIES

MONTHLY - ONE PENNY.

Freedom

MAY, 1916.

COMPULSION FOR ALL

THE TRAGEDY OF IRELAND

MONTHLY - ONE PENNY.

Freedom

SEPTEMBER, 1916.

WORKERS AND PEACE CONFERENCE

CONSCRIPTION FOR IRELAND

MONTHLY - - - ONE PENNY.

Freedom

FEBRUARY, 1917

AN UNHOLY ALLIANCE

LABOUR PARTY CONFERENCE

MONTHLY - - ONE PENNY.

UNIDAD DE TODAS
LAS FUERZAS PATRIOTICAS
DE NICARAGUA
POR EL DERROCAMIENTO
DE LA DICTADURA SOMOZA
¡VIVA EL FRENTE SANDINISTA
DE LIBERACIÓN NACIONAL !!!

"[For the unification of all the Nicaraguan patriotic forces in toppling the Somoza dictatorship: Long live the Sandinista Liberation Front for National Liberation]," art and printing by Jane Norling, 1978.

CRANKING IT OUT
OLD SCHOOL STYLE
THE LOST LEGACY OF GESTETNER ART
Lincoln Cushing

"Freedom of the press is guaranteed only to those who own one."[1]

Every society has its pecking order, and printing is no different. Equipment matters. At the top of the heap are the big presses—the giant Goss web machines that churn out daily newspapers, the high-speed Solna sheetfeds for beautiful color posters, the elegant Heidelberg Windmill letterpresses for art prints. At the bottom are the lowly duplicators, those machines not even called presses that are the Volkswagen Bugs of the reproduction world. People of a certain age may remember the two offset workhorses of this stratum, the A.B. Dick 360 and the Multilith 1250. But even below these machines, in the very dark recesses of the reproduction food chain, lay the spirit duplicators and mimeographs.

Before photocopiers[2] took over the short-run end of making copies in the late 1970s and '80s, messy and relatively inexpensive machines called Dittos and Mimeographs and Gestetners ruled the earth. Virtually every school, office, and union hall had one in the back room, usually surrounded by reams of paper and the unmistakable odor of fresh solvent. There were two competing technologies. Both used prepared stencils on rotating drums, but while the "spirit"

duplicators (like the Ditto) relied on a very aromatic methyl alcohol to create the image on paper, the other processes used ink. And although the stencils were originally produced with a pen or typewriter, by the mid-1960s stencil-burning machines pioneered low-cost scanning of original art—both flat and full-color were possible.

This, coupled with the fact that by swapping or cleaning the ink drums one could print multiple colors in subsequent passes, offered some of the earliest opportunities for community-based artists and organizers to make colorful flyers and newsletters. It may be hard to believe in this day and age, when "color separation" isn't even a conscious act and photographs can be effortlessly published on a webpage, but this quaint technology was a breakthrough aesthetic boon to democratic media. These machines could also make copies on legal-size paper (8 1/2 x 14") that was often folded in half for magazine work.

Among the first to experiment with these artistic possibilities was Communication Company (CC), founded in San Francisco's Haight-Ashbury district by Chester Anderson and Claude Hayward in January of 1967. This was the epicenter of the new counter-culture, and every movement needs a medium. Hayward describes how it started:

Around December 1966 we met Chester Anderson. I don't exactly remember the date or in which context, but somehow or another he moved in with us at 406 Duboce Street [San Francisco] which became the first Communication Company location. Chester was the one who was aware of the Gestetner and came up with the idea of getting this machine. He had some money left over from royalties from his science fiction fantasy novel *The Butterfly Kid*, which had been published by Pyramid Books. He had a few hundred bucks and we went down to the Gestetner company and we managed to walk out of there with the Gestetner and the Gestefax scanner, based on his down payment and my signing for it because I was the one with a job [at *Sunday Ramparts*].[3]

The Communication Company

haight/ashbury

OUR POLICY
 Love is communication.

OUR PLANS & HOPES
+ to provide quick & inexpensive printing service for the
 hip community.
+ to print anything the Diggers want printed.
+ to do lots of community service printing.
+ to supplement The Oracle with a more or less daily paper
 whenever Haight news justifies one, thereby maybe adding
 perspective to The Chronicle's fantasies.
+ to be outrageous pamphleteers.
+ to compete with the Establishment press for public opinion.
+ to revive The Underhound, old North Beach magazine of satire
 & commentary that was instrumental in ending a police
 harrassment routine very like the present one.
+ to function as a Haight/Ashbury propoganda ministry, free
 lance if needs be.
+ to publish literature originating within this new minority.
+ to produce occasional incredibilities out of an unnatural
 fondness for either outrage or profit, as the case may be.
+ to do what we damn well please.
+ to keep up the payments on

OUR MAGNIFICENT MACHINES
* one brand-new Gestetner 366 silk-screen stencil duplicator.
* one absolutely amazing Gestefax electronic stencil cutter.

WITH WHICH WE CAN
+ print up to 10,000 nearly lithographic quality copies of
 almost anything we can wrap around our scanning drum.
+ on any kind of paper up to 8½ by 14 inches (this being
 basically an office machine).
* with any kind of art, including half-tones.
* on both sides of the page.
+ in up to four colors with adequate registration (office machine).
* with all manner of outrageous innovations.
* all in a very few hours.

WE NEED ALL THE HELP WE CAN GET!

WE NEED
+ printing orders.
+ Haight Street reporters.
* a whole lot of scripts for maybe publication.
+ writers for The Underhound.

claude & chester

626-2926

we deliver

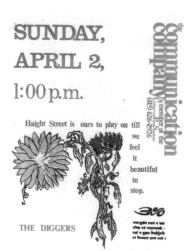

SUNDAY,
APRIL 2,
1:00 p.m.

Haight Street is ours to play on till we feel it beautiful to stop.

THE DIGGERS

Two flyers printed by Communication Company, 1967.

Communication Company cranked out an endless stream of flyers and handbills for community groups such as the San Francisco Mime Troupe and the Diggers as well as scores of events. As their promotional flyer stated, they planned to "Provide quick & inexpensive printing services for the hip community." They also aspired to "Produce occasional incredibilities out of an unnatural fondness for either outrage or profit, as the case may be" and to "Do what we damn well please." Their cutting-edge equipment consisted of a brand-new Gestetner 366 silk-screen stencil duplicator and "one absolutely amazing Gestefax electronic stencil cutter." Many of their works were proudly labeled "Gestetnered by Communication Company." According to Hayward, the artistic force behind the experimental graphic work was William "Billy" Jahrmarkt, who joined up with CC just about the time that Hayward was getting pushed out over personality clashes with Anderson. Hayward explains the exploration of color and graphics:

I had some prior printing experience— I'd done some pasteup with the *L.A.*

Free Press and I had worked on a letterpress with cold type. I understood the concepts of registration and color separation, but of course that was higher end work than we were doing at the time. I was always the "hands-on" guy, I don't know if Chester ever ran that machine. I started playing around with the possibilities, and the first color stuff we did was with several stencils overprinted with simple color. I wasn't approaching this from an artistic standpoint so much as I was being pragmatic: "Let's get this work done." As people asked for certain things we tried to see what we could do. I wasn't an artist.

Up until around June or so we didn't make any leaps into new territory. The person who really opened the door to using color was William Jahrmarkt, known locally as "Billy Batman." I think he had a big art reputation in NYC before SF, but I am inferring that from what I heard at the time. He was the father of "Digger Batman," of whom Kirby Doyle wrote about in the poem "The Birth of Digger Batman." Jahrmarkt was your classic brilliant crazy scion of a wealthy family. There was lots of money, so he got to indulge himself in his art and his heroin. He did some amazing work. He started really, really pushing the limits—bleeds, color changes, streaks, and more.

The ink came in tubes. We just cleaned it out to change color. It didn't use a drum. There were two cylinders with a silkscreen belt running on them. I guess we changed those. Ideally, each ink color would have its own screen. The stencil was a thin waxy-rubbery material backed with paper and it was critical to get this on right while peeling the paper backing away. It also accepted the standard paper mimeo stencil, and we used these on some of the text stuff we did ourselves. When someone brought in "camera-ready" copy, it went through the Gestefax. The Gestetner was a very well designed machine, very tidy to operate. It never gave us any trouble at all. We just had to keep it clean. The Gestefax was flawless. It was the first scanner, pre-digital technology. It actually produced a stencil by burning a hole with an electric spark. So we played with that, a lot. The Gestefax scanner derived, I believe, from early facsimile transmission devices, before what we now call "fax."

Communication Company lasted less than a year, after internal struggles blew it apart.

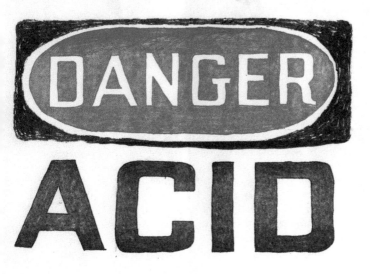

McG/CC

This page: "Danger: Acid," by "McG," 1967.
Opposite page: "Press release: The Council for the Summer of Love," by Communication Company, 1967.

[By August of 1967] Chester had gotten pretty crazy and I'd lost access to the machinery. He'd always done a lot of speed, he was a heavy user. There was a point that he shanghaied the machines and ran off with them. He had some place in Richmond or Alameda, and I remember going out there to talk to him and he took a shot at us out his window. We left.

The Digger folks themselves basically ended up seizing the machines from Chester. I'm not sure when Batman got his hands on them, but it was after his child was born that I got to know him. There was probably a good year of really interesting stuff that came out after I was gone.

The examples of CC printing that illustrate this article were provided by countercultural collector and historian Richard Synchef, gathered from the late San Francisco writer Margo Patterson Doss. Doss had contributed a sum of money to support the printing of a Richard Brautigan's poem "All Watched Over by Machines of Loving Grace" both as a broadsheet and later as a one-off booklet, and in return she received a copy of each handbill they printed.

By the mid-1970s, another Gestetner movement had gained momentum in the

PRESS RELEASE

PRESS RELEASE

THE COUNCIL FOR THE SUMMER OF LOVE

OF THE HAIGHT_ASHBURY COMMUNITY INVITES YOU TO A

PRESS CONFERENCE TO PRESENT THE UNIFIED, POSITIVE FORCES

ACTIVELY INVOLVED IN THE COMMUNITY.

REPRESENTED WILL BE . . .

THE KIVA
THE STRAIGHT THEATER
THE CHURCH OF ONE
THE FAMILY DOG
THE DIGGERS AND PROMINENT INDIVIDUALS

PLACE 1757 WALLER TIME 10:00 AM

DATE: APRIL 5, 1967 SAN FRANCISCO PLANET EARTH

GESTETNERED BY
COMMUNICATION COMPANY) (UPS)

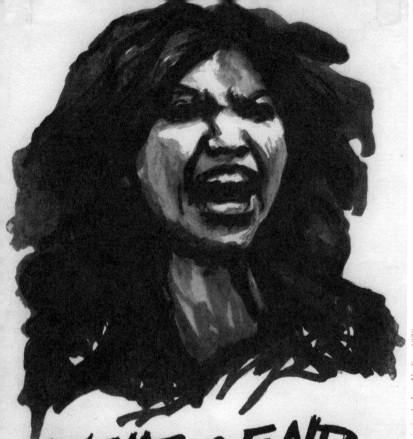

FIGHT TO END VIOLENCE AGAINST WOMEN

"Fight to end violence against women," art and printing by Jane Norling, 1978.

Bay Area. A critical mass of neighborhood arts programs and community-based artists were prolifically making murals, posters, theater, and other cultural forms. Many of these organizations were fueled by the Comprehensive Employment and Training Act (CETA, 1973-1982), a U.S. federal program to train workers and provide them with jobs in the public service sector. Full-time jobs were provided for a period of twelve to twenty-four months in public agencies or private nonprofit organizations. The intent was to impart a marketable skill that would allow participants to move to an unsubsidized job. It was the largest public jobs program since the mighty Federal Arts Project of 1935-1943, and it was a reminder about how important public funding in the arts can be. Approximately $50 to $65 million was spent on public arts programs during the peak years, 1978 and 1979. CETA funded over ten thousand artists and over six hundred projects in two hundred locations nationwide.

Once again, the lowly Gestetner came to the rescue in helping spread the word, and in some cases was the word.

Uncontestedly, NAP's [San Francisco Art Commission's Neighborhood Arts Program] design and printing of colorful flyers for community arts activities is the program's best-known service. . . An average day's output includes design of two to four flyers and printing of eight editions, many designed by the requesting group, of from 500 to 1000 each. They run through about 120,000 pages monthly.[4]

Accounts at the time enthused about the services:

Up a narrow wooden staircase in a complex of offices furnished with second-hand couches and discards from other city offices, a NAP client will find a clanking Gestetner press, ringing phones, and bustling people. . . .

Printing posters is the most apparent service that NAP provides. Throughout the community, multicolor Gestetner flyers announcing a play, a workshop, an art show, or a festival, are posted in Laundromats, in coffeehouses, on telephone poles; they can be picked up in head shops, museums, or churches. Any community agency active in the arts can benefit from the designs of the NAP staff artists. Stationery,

ALL INDIAN NATIONS ARTS FESTIVAL 1980

JUNE 20 — 22
FORT MASON-PIER 2
LAGUNA at MARINA
SAN FRANCISCO

FRIDAY 7-12 PM
SATURDAY 10 AM — 12 PM
SUNDAY 10 AM — 6 PM

DISPLAY, SALE, TRADITIONAL FOOD & POW-WOW

Admission: Adults $2, Sr. Citizens & students $1.50. Children under 12 free with adults.
For more info call 824-5703

Sponsors: All Indian Nations Arts Co-op
American Indian Center
Fort Mason Foundation
Good Samaritan Community Center
Interfaith Friendship House
National Park Service/Golden Gate National Recreation Center
S.F. Hotel Tax Fund

Free parking & shuttle bus service at Crissy Field.
No parking at Fort Mason.
Bus lines: 19, 22, 30 & 47.

© 1980 H. TSINNHAHJINNIE

Above: "All Indian Nations Arts Festival 1980." Artwork by Hulleah Tsinnhahjinnie.
Opposite page: "My name is Assata Shakur and I am a Black revolutionary" by Miranda Bergman, 1977 (printed by Jane Norling).

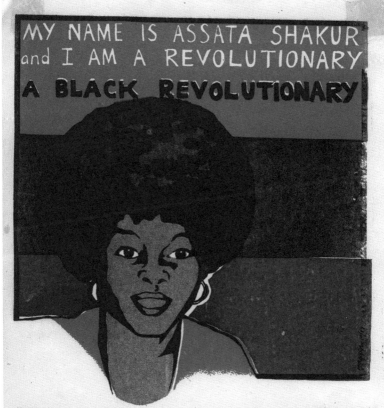

MY NAME IS ASSATA SHAKUR and I AM A REVOLUTIONARY
A BLACK REVOLUTIONARY

"THIS IS NOT THE TIME TO FEEL DEPRESSED OR DEFEATED. THIS IS NOT THE TIME TO FORGET ABOUT STRUGGLING, OR TO FORGET ABOUT ALL THE SISTERS AND BROTHERS WHO HAVE BEEN RAILROADED INTO DUNGEONS.
RATHER, IT IS THE TIME TO FEEL OUTRAGED, TO FEEL DETERMINED, TO FIGHT AGAINST THIS GOVERNMENT TOOTH AND NAIL, NOT FOR WHAT IT IS DOING TO ME, BUT FOR WHAT IT IS DOING TO US ALL.
I WOULD LIKE TO MAKE THIS A BETTER WORLD FOR MY DAUGHTER AND FOR ALL THE CHILDREN OF THIS WORLD, FOR ALL MEN AND WOMEN OF THIS WORLD."

After three consecutive trials in which she was aquitted, Assata Shakur, revolutionary Black leader, was convicted in New Jersey in March, 1977 by an all-white jury on frame-up charges of murder and illegal weapons charges. Her comrade Sundiata Acoli is serving life plus 30 years from the same incident. This railroading and legal lynching are part of the brutal attacks this government makes on Black Revolutionaries. Yet they continue to struggle from behind prison walls for the liberation of their people.
FREE ASSATA! FREE SUNDIATA! SUPPORT FOR THEM IS SUPPORT FOR THE BLACK LIBERATION MOVEMENT!

GONNA RISE AGAIN GRAPHICS
Collective Makes Politics A Priority

Two years ago four graphic artists began working together for the common purpose of combining their artwork with their political commitment. Two, Ron and Oona, had worked in the Moe Valley Silkscreen Collective, while others knew each other from the now defunct Cultural Workers Front, a political cultural coalition in the Bay Area. All had had experience in the visual arts, ranging from professional training in drafting, design, and fine arts, to self-taught poster production.

When the four formed Gonna Rise Again Graphics, their intent was clear: they all wanted to use their graphic skills to serve the movement to defeat the U.S. system of economic and political domination. They all agreed that it was important to develop cultural forms in conjunction with this political movement because, in the words of one member, "This system affects our most intimate relationships with each other, as well as other aspects of our culture, our art forms, poetry, and music." Although they all agreed on a common purpose at the time they formed, the means to accomplish these ends was not completely clear.

Today Gonna Rise Again Graphics has two years of experience as a working collective behind them. They have produced leaflets and flyers for community and labor organizations, designed and illustrated books for

Peoples Press, mounted several exhibitions of educational artwork within the peoples' food system and at neighborhood sites. Groups they've worked for and with include the Bay Guardian Strikers, the Richmond Committee Against Police Crimes, the July Fourth Coalition, and Non-Intervention in Chile. Their ideas and work methods have developed over the course of their two years of work, and continue to do so.

G.R.A. is somewhat of a hybrid organization — part business, part service, and part political project. Although the group charges fees for its work (on a sliding scale), they are not a commercial business. All members work outside the group for economic survival; fees and fundraising projects only cover their production costs. This situation allows the group a certain flexibility which they value over the additional strain of divided energies and time. In some respects, this flexibility is indispensable to their modus operandi, because it affords them the freedom to be politically discriminating about the projects they work on and allows them to work in a more thorough way than commercial studios.

In contrast to graphic arts business, which turn out large volumes of work and often have superficial

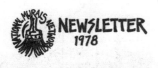

THE ARTS BIWEEKLY

The Bay Area Newsletter of Art & Politics No. 54, Aug. 15, 1977

Continued on p. 5

"La Peña," Commonarts, Berkeley, see p. 6

posters, and a variety of business forms are printed by this process and used by organizations as diverse as the Galeria de la Raza, the de Young Museum for its Trip-out Truck, and a children's center for a fund-raising festival.[5]

A small community-based arts organization called Intersection, currently still alive and called Intersection for the Arts, published a wonderful biweekly with essays, reviews, news—and art.

And the new National Murals Network published their first newsletter (later to become the *Community Murals Newsletter*), featuring the fresh wall art at Berkeley's La Peña Cultural Center.

Artist/printer Jane Norling describes what it was like:

The greatest challenge was creating a design and printing 500 copies in a day in context of other such work. The

Top: *The Arts Biweekly: The Bay Area Newsletter of Art & Politics*, issue #54, November 1, 1977; published by Intersection. Produced by the San Francisco Art Workers Coalition.
Bottom: Cover for *National Murals Network Newsletter*, 1978. Color separation of mural at La Peña Cultural Center, Berkeley, CA.
Right: Jane Norling and Tony Chavez in print shop, San Francisco, 1979.

Gestetner process allowed us to create artwork with pencil and marking pens directly on letter or legal-size paper, affixing strips of type, gluing paper with typewriter text to layout, placing on scanning drum and etching stencils. The challenge was to produce clean copy to prevent spending an inordinate amount of time masking out areas on stencil etched by shadows from pasted paper, dust, etc.

Limitation: scans from photography produced murky color prints. My workaround was to trim photos in erratic shapes to catch the eye, so content of images was of less of a concern. Scans were ersatz CMYK, exact registration in printing impossible. The technology was the message—a certain inkjet quality of fluid ink on matte paper, ill-defined edges, but that's what it was. We were thrilled to have capacity to turn around color work so rapidly.[6]

Artists often push technology in ways that are unexpected and engaging. Community artists add the extra spin of making that creativity part of a process that gives voice to the underrepresented

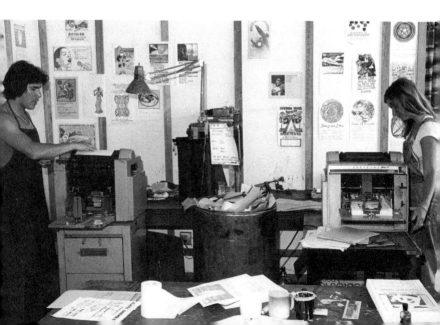

and the oppositional. But much of this history encompasses what art scholar Gregory Sholette calls "dark matter," the marginalized massive output of ephemera that is invisible to mainstream cultural and academic institutions. It's up to us to document, analyze, and publish our own cultural history exploring "forgotten" materials such as those in this essay. ⑤

Credits

A version of this essay first appeared 10/19/2010 in the online magazine *Voice*, published by AIGA, the professional association for design. Thank you Steve Heller for your support and encouragement. All Communication Company flyers courtesy Richard Synchef, all 1977-1978 flyers and photos except for *Arts Biweekly* and "All Indian Nations Arts Festival" courtesy Jane Norling. *National Murals Network Newsletter* courtesy Timothy Drescher. *Arts Biweekly* and "All Indian Nations Arts Festival 1980" from author's collection. Scans by author.

Notes

1. A.J. Liebling, *The Press* (New York: Ballantine Books, 1961), 30.
2. Purists use this generic term when describing such machines, but in truth, the groundbreaking company was Xerox. The first successful commercial photocopier was the Xerox model 914, introduced in 1960. In 1969 Daniel Ellsberg tediously copied 7,000 pages of top-secret military documents on a Xerox model 812 belonging to Lynda Sinay, who ran a small advertising agency on Melrose Avenue in Los Angeles. His act of unauthorized duplication helped to end the war in Vietnam.
3. Phone interview with author, October 1, 2010.
4. Text from transcript, *The Arts and the Community Oral History Project*, interview conducted by Suzanne B. Riess, 1978.
5. Barbara Y. Newsom and Adele Z. Silver, *The Art Museum as Educator: A Collection of Studies as Guides to Practice and Policy* (Berkeley: University of California Press, 1978).
6. E-mail correspondence with author, September 11, 2010.

Opposite: "In Rememberance of the Attica Massacre," art and printing by Jane Norling, 1978.

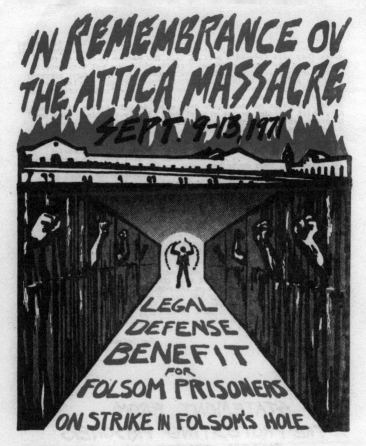

IN REMEMBRANCE OV THE ATTICA MASSACRE
SEPT. 9-13, 1971

LEGAL DEFENSE BENEFIT FOR FOLSOM PRISONERS ON STRIKE IN FOLSOM'S HOLE

SPEAKERS: Angela Davis, Attorney James F. Smith

CULTURAL ENTERTAINMENT: The Family Nitoto— Political Theater with African Percussion; Gwen Avery— Blues Gospel Soul Singer

POETS: Ahimsa Sumchai, Quentin R. Hand, Max Schwartz, Luz Guerra, Masaba (former member ov Th Last Poets)

SLIDES FOOD CHILDCARE Donation: $3.00

WEDNESDAY, SEPT. 13, 1978 7:30 PM
PEOPLES CULTURAL CENTER, 721 VALENCIA, S.F.

The Folsom Brothers stand STRONG united white black latino striking for human decency --to touch their families, to telephone their families --to have decent doctors --to have amnesty from reprisals because of the strike, etc.

This event sponsored by the Folsom Support Committee, P.O. Box 31223, San Francisco, CA 94131. 626-3131

printed by the S. F. Neighborhood Arts Program - au

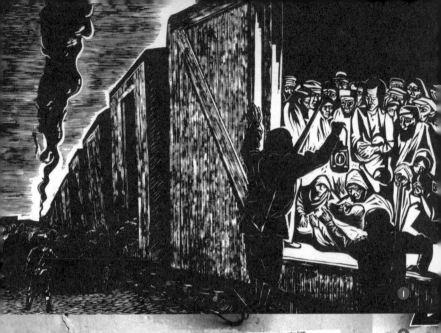

1

2

ART OF REBELLION
Oaxacan Street Art in a Mexican Context

Deborah Caplow

The remarkable phenomenon of street art in Oaxaca today readily calls to mind the socially concerned artists of an earlier era in Mexico. Starting in the 1920s and continuing into the 1960s, artists' groups in Mexico came together to express their opposition to injustice and oppression. Initially they worked to support the goals of the Mexican Revolution (1910–1920); artists in the 1920s began to see themselves as dynamic participants in a new society, responsible for communicating revolutionary ideology to the Mexican people and for helping the oppressed masses achieve political and economic equality. Painters, printmakers, and sculptors participated in a Mexican artistic renaissance that constructed political and historical meanings through a rich vocabulary of images. In addition to mural paintings, Mexican artists began to use prints to convey clear political messages. In the 1920s muralists such as David Alfaro Siqueiros, José Clemente Orozco, Xavier Guererro, and Máximo Pacheco made woodcuts to illustrate *El Machete*, the periodical of the artist's union, and from the 1920s to the 1960s numerous artists created prints as illustrations for other leftist publications.

Soon after the Revolution, Mexican artists discovered the prints of José Guadalupe Posada (1852–1913), who became immensely influential in Mexican art. Posada had worked in virtual anonymity, creating thousands of engravings that had popular appeal for the citizens of Mexico City. He provided witty, satirical images to illustrate periodicals, broadsides, and popular ballads. Posada's *calaveras* (skeletons)

depicted a wide assortment of themes, including political events and festive occasions. These prints came to be associated with the Days of the Dead in Mexico, and appeared (and still do) every November, along with sugar skulls, toy coffins, and other playful allusions to death. Posada also used to lampoon politicians and public figures, a practice that greatly appealed to Mexican artists of the post-Revolutionary period.

In 1934, Siqueiros, Leopoldo Méndez, Pablo O'Higgins, Luis Arenal, and other artists and writers formed the Liga de Escritores y Artistas Revolucionarios (League of Revolutionary Writers and Artists, LEAR). During the three years of its existence LEAR's

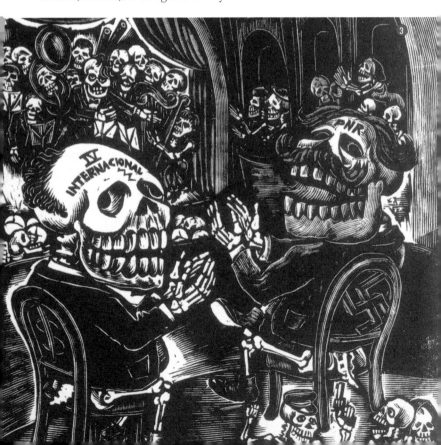

membership included hundreds of artists and intellectuals, including painters, photographers, musicians, theater directors, actors, and writers. The members fought for the rights of the working class and looked to the practices of agit-prop in the Soviet Union as a method of influencing the masses, as they produced prints, banners, backdrops, and pamphlets for a variety of movements and causes. Although the artists of LEAR were strongly against the Mexican government in the beginning, when Lázaro Cárdenas became president in 1934, they began to ally themselves with his more progressive labor, agrarian, and educational policies. LEAR also supported the Spanish Republic during the Spanish Civil

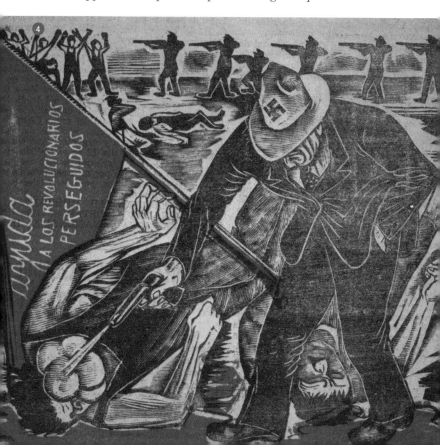

War and in 1937 sent a delegation to Spain with an exhibition of paintings and prints. Between 1934 and 1937, the artists of LEAR made numerous images with anti-Fascist messages, to combat the rise of Fascism in Mexico and abroad. These were typically inexpensive prints on cheap paper meant for a wide, popular audience.

Prints were a familiar and popular medium in Mexico, and Méndez, reviving the spirit of Posada in his powerful graphic work, became one of the most important printmakers of the time. Méndez was the first artist after Posada to recognize the true potential of printmaking for political satire and the first to make direct imitations of Posada's calaveras. In 1934, on the first cover of LEAR's magazine *Frente a Frente*, Méndez lampooned muralist Diego Rivera in *Calaveras del Mausoleo Nacional* (fig. 3), using the calavera form to portray Rivera at the inauguration of the Opera House at the Palacio de Bellas Artes (Palace of Fine Arts). Here Méndez labeled Rivera as a reactionary and a government collaborator (a position Méndez and other members of LEAR had taken because of Rivera's pro-Trotsky leanings and his government commissions). A dollar sign (used for the Mexican peso) on the back of the muralist's chair and a swastika on the chair of the politician next to him clearly communicate Méndez's opinions with mocking humor.

In addition, Méndez produced such anti-Fascist works as *Fascism II* (fig. 4), which denounced the brutal attacks on unarmed strikers by Mexican Fascists of the Acción Revolucionaria Mexicana (ARM). In this print Méndez demonstrated his familiarity with the style of Posada with his use of simplified forms and the lively immediacy of the image. Prints such as these focused on the issues facing Mexico in the mid-1930s and were addressed to leftist artists and activists as well as to the working class.

In 1937, Méndez, Arenal, and O'Higgins founded the Taller de Gráfica Popular (Popular Graphic Arts Workshop, TGP), a printmaking collective in Mexico City. A unique undertaking, from 1937 to 1960 the TGP was the only major center for the creation of political prints anywhere in the world; the TGP

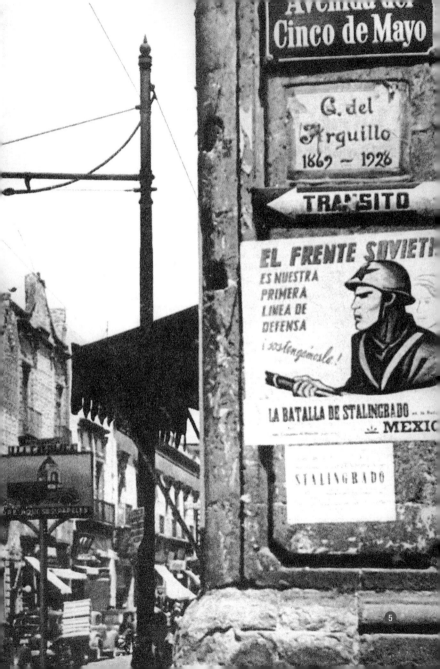

the historic center of Mexico City (fig. 5).

The TGP's prints often focused on themes from Mexican history: iconic figures of the Revolution such as Emiliano Zapata, or the appropriation of the oil industry and agrarian reform during the Cárdenas era. Méndez's brilliantly satirical print *El Embajador Lane Wilson "Arregla" el conflicto* (fig. 6) refers to the American Ambassador's lamentable involvement in the coup that led to the murder of President Francisco Madero in 1913. This image communicates the sense of corruption and denial that continue to plague Mexican politics to this day.

The work of the TGP was also distinguished by its international focus, especially during the years leading up to World War II and during the war. From 1937 to 1945, Méndez and other members of the Taller de Gráfica Popular built upon the work of LEAR and continued to produce powerful anti-Fascist images as they turned their attention from Mexico to Europe. Méndez's 1942 *Deportación a la muerte* (fig.1, also called *El tren de la*

grew to a membership of about twenty-five. Working collaboratively, they created high-quality graphic work in the form of posters, pamphlets, broadsides, brochures, portfolios, and book illustrations. Their images portrayed current and historical events, attacking injustice, inequality, poverty, and corruption. Though they also sold fine art copies of their work, the street was their forum; many of the prints of the TGP were directed to a wide public, both as portable prints for mass distribution and large-scale posters pasted on the walls of

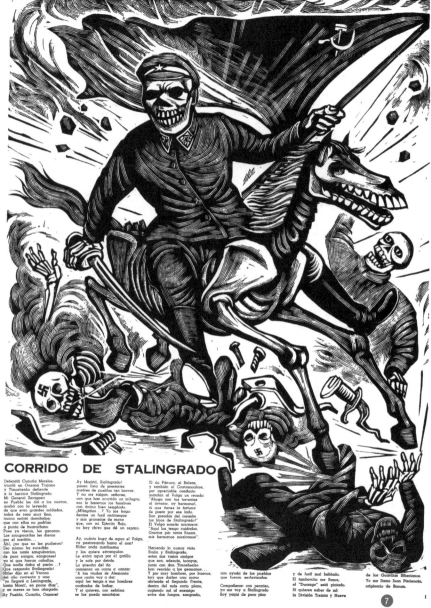

CORRIDO DE STALINGRADO

Defendió Cuautla Morelos,
triunfó en Oaxaca Trujano
y Timoshenko defiende
a la heroica Stalingrado.
Mi General Zaragoza
en Puebla les dió a los zuavos,
acabó con la leyenda
de que eran grandes soldados,
todos de rosa muy fina,
nunca serían derrotados;
que con ellos no podrían
a punta de huarachazo.
Pues ya vieron, los ganaron.
Los zacapoaxtlas les dieron
por el meztitle...
Ah!, ¿no que no les pudieron?
Eso mismo ha sucedido
en los nazis sanguinarios,
de pura sangre, sangrones!
ya ni que fueran caballos.
Que nadie daba el perdón...?
Que responda Stalingrado!
Hitler dijo en el verano
del año cuarenta y uno
"yo llegaré a Leningrado,
hasta Moscú, en pocos días"
y en meses se han alargado.
Ay Puebla, Cuautla, Oaxaca!

Ay Madrid, Stalingrado!
pasen lista de presentes
madres de pueblos tan bravos.
Y no me salgan, señores,
con que han ocurrido un milagro;
eso lo hacemos los hombres
con ánimo bien templado.
¿Milagritos...? Yo los hago:
denme un fusil antitanque
y mis granadas de mano
que, con mi Ejército Rojo,
no hay chivo que dé un reparo.

Ay, cuánto buey de agua el Volga,
va pastoreando hasta el mar!
Hitler anda marihuano
y los quiere estrangular.
Le entra agua por el gatillo
y le sale por detrás.
La sirenita del río
comienza un canto a cantar:
"A las viudas de Alemania
una razón voy a dar:
aquí les tengo a sus hombres
acabados de bañar.
Y si quieren, con neblina
se los puede amortajar.

El río Pánuco, el Balsas,
y también el Coatzacoalcos,
por apreciable conducto
mandan al Volga un recado:
"Ahoga con tus torrentes
al invasor, ay hermano!,
tú que tienes la fortuna
de pasar por ese lado.
Son prendas del corazón
tus hijos de Stalingrado!"
El Volga nomás murmura:
"Aquí los tengo cuidados.
Gracias por tanta fineza,
mis hermanos mexicanos".

Haciendo lo nunca visto
Stalin y Stalingrado,
estos dos viejos amigos
que son, además, tocayos,
junto con don Timoshenko
han vencido a los germanos...
Y por muy hombres, por buenos,
hoy que darles una mano
abriendo el Segundo Frente,
dentro del más corto plazo,
cogiendo así al enemigo
entre dos fuegos, sangrado,

con ayuda de los pueblos
que fueron esclavizados.

Compañeros: con permiso,
ya me voy a Stalingrado
Soy yaqui de poco pico

y de fusil mal hablado.
El tamborcito me llama,
el "Durango" está pintado.
Si quieren saber de mí:
la División Treinta y Nueve

de los Guardias Siberianos.
Yo me llamo Juan Paciencia,
originario de Bacum.

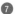

I

8

muerte) depicts Jewish prisoners being transported to Auschwitz, demonstrating Méndez's early awareness of the Nazis' extermination policy. The print is a remarkable portrayal of this theme; Méndez included significant details, such as the smoke from the engine of the train, which is eerily reminiscent of the crematoria. This powerful black-and-white print is one of the earliest artistic images of the Holocaust, referring directly to the extermination of Europe's Jewish population.

Méndez also portrayed the Soviet resistance against the Nazi invasion of Russia in his *Corrido de Stalingrado* (fig. 7), a dynamic work that again shows the influence of works by Posada, for example, his *Calavera revolucionaria* (fig. 8).

Although Méndez died in 1969, his images continue to exert a powerful influence in Mexico, and to this day leftist publications and posters frequently appropriate his work. In 1992, a group of activists in Mexico City recontextualized one of Méndez's most engaging images, *El serpiente cascabel* (The Rattlesnake), from 1944. Méndez himself based the image of a serpent on a section of the Aztec *Madrid Codex*, and the 1992 poster (fig. 9) also refers to the pre-Columbian past, in a text protesting the five-hundred-year anniversary of the Conquest. In 2001, a flyer (fig. 10) announcing a meeting of campesinos in Oaxaca utilized Méndez's *La carreta*, an indication of the strength of his images and a statement that the rural poor in Mexico still live in the same circumstances as they did in Méndez's time. In Oaxaca in June 2008 one of

Méndez's most forceful political posters, originally created for a miners' strike in 1950, was incorporated into an announcement of a political meeting (figs. 11 & 12). His prints are used freely by political organizations, without attribution, in a sense acting as a kind of image base for contemporary political publicity.

In fact, the prints of Méndez and the TGP retain their power because Mexico continues to be a divided society, plagued by vast social inequality, especially in regard to the indigenous peoples of Mexico. The Zapatista uprising in the State of Chiapas in the early 1990s and the rebellion in Oaxaca in 2006 were responses to conditions unchanged since colonial times, in spite of the promises of the Mexican Revolution. In the wide gap between rich and poor, communities in the countryside go without roads, water, and electricity, with little or minimal educational opportunity, while the urban poor also live in destitution.

In 2006 in Oaxaca the impulse for social change transformed the politics of the city and the state, creating a mass

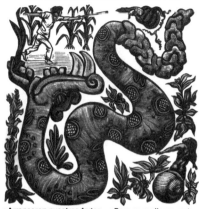

12 DE OCTUBRE DE 1992
A 500 AÑOS DE LA INVASION
SEGUIMOS RESISTIENDO PORQUE:

• Arrancaron nuestros frutos
• Cortaron nuestras ramas
• Quemaron nuestro tronco

• Pero no pudieron matar nuestras raíces

Apartado postal 14-339 México. 14 D.F.

movement that shut down the Ciudad de Oaxaca from June to November and almost toppled the state government.

The causes of the political crisis in Oaxaca were fairly straightforward. For many years schoolteachers from throughout the state had protested their poor salaries, inadequate school buildings, and, recently, the closure of teachers' normal schools in rural areas. Until 2006, these protests had taken place every year for twenty-five years in the *Zócalo* (central plaza) of the City of Oaxaca, more or less tolerated by the authorities. But in June 2006

2° ENCUENTRO CAMPESINO REGIONAL DE OOCEZ

24 DE MARZO, 10 Hrs. EN LA PAZ YOSOÑAMA, ÑUMI, TLAXIACO, OAXACA

POR LA LIBERTAD DE LOS PRESOS POLITICOS

- Sixto Santiago Antonio
- Rafael José Miguel
- Nicolás José Santiago

OOCEZ

CONTRA EL DESPOJO DE TIERRAS DE SAN PEDRO YOSOTATO, NUYOO, TLAXIACO, POR LOS POBLADOS ZIMATLAN Y NOPALERA, PUTLA, OAXACA

⑩ the state government, under the direction of Ulises Ruiz Ortiz, the conservative governor of the state, responded violently to the teachers' strike in the Zócalo, sending in state police to expel the teachers and their supporters. The tear gas they used covered the entire center of the city. This assault on the striking teachers was the last straw in a series of repressions. The governor's actions also included the alteration of a number of public spaces in Oaxaca, the most unpopular of which was the "renovation" of the Zócalo, the cultural heart of the city. The state government cut down trees and replaced ancient stones with concrete paving level with the street (more convenient for armored vehicles). Other parks and neighborhoods in Oaxaca were similarly altered, to the distress and dismay of the inhabitants of the city. The large contracts awarded for these projects were widely considered to benefit the governor's cronies. But it was the brutality against the teachers that ignited the flames of rebellion, angering and mobilizing the general population.

After the assault on the teachers, Oaxaca exploded into political action. Over four hundred groups formed a grassroots coalition, Asamblea Popular de los Pueblos de Oaxaca (Popular Assembly of the Peoples of Oaxaca, APPO), and began a series of protests against the violence, corruption, and injustice of the state government. From June to November 2006 the struggle for control of the city created a tense but dynamic atmosphere, as the city was barricaded, thousands of people took to the streets, the annual cultural festival, the Guelaguetza, was cancelled, and tourism came to a halt. APPO took over radio and television stations in Oaxaca and broadcast messages to the people.

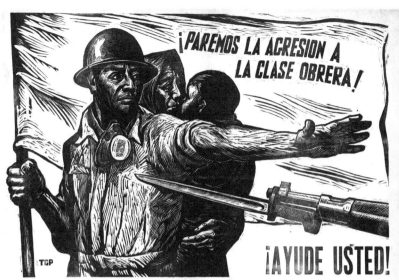

¡PAREMOS LA AGRESION A LA CLASE OBRERA!

¡AYUDE USTED!

A LOS HUELGUISTAS DE PALAU, NUEVA ROSITA Y CLOETE

Envíe su donativo a Raúl Torres B. Campo número 2 Palau, Coahuila

Sindicato Industrial de Trabajadores Mineros, Metalúrgicos y Similares de la República Mexicana

Unión General de Obreros y Campesinos de México

contra la represión laboral
¡la unidad en las luchas obreras!

¡PAREMOS LA AGRESION A LA CLASE OBRERA!

por la reinstalación
a sus puestos de trabajo !

Hugo Ortega
(gamesa)

Óscar Medina
(suajes y preparaciones)

mítines por la reinstalación

Frente
Único de
Trabajadores

COMITÉ DE PRESOS DE
SANTA MARIA IXCOTEL, OAXACA

COSID
CTYOO-ISSSTE

DENUNCIA OBRERA

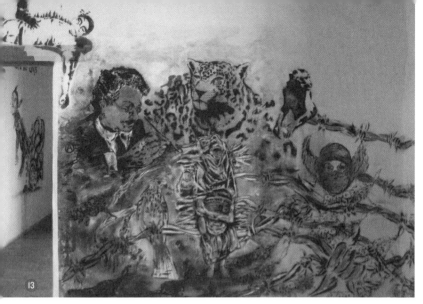

During these turbulent months, artist-activists within APPO began to produce graffiti, stencil art, woodblock and silkscreen prints, and paintings, starting a street art movement that peaked from 2006 to 2008. Oaxaca was already a city of printmakers—some of its most renowned artists have produced prints as a major part of their practice, including Rufino Tamayo, Francisco Toledo, and Rodolfo Morales, and in contemporary Oaxaca printmaking flourishes as a primary art form, with a great number of successful graphic artists and many printmaking studios. Much of the printmaking in Oaxaca reflects the influence of Tamayo and Toledo, in fact, to the point that there is what is termed a "Oaxaca style," characterized by brilliant colors and imaginative figuration, often referring to folk art and indigenous culture.

Activist street artists who emerged from the uprising of 2006 thus worked in a milieu of an established graphic tradition, and some of them attended the Escuela de Bellas Artes at the Universidad Autónoma Benito Juárez de Oaxaca (the School of Fine Arts at the Benito Juarez Autonomous University of Oaxaca). They differed from the mainstream of Oaxacan printmaking in significant ways,

however: they worked collaboratively, their prints were character-ized by political immediacy, and they worked in the spirit of earlier Mexican printmaking, often directly inspired by Méndez and other members of the TGP, creating similar kinds of images and using the walls of the city in the same manner as their predecessors.

Some of the young artists active in APPO formed the collective Asamblea de Artistas Revolucionarios de Oaxaca (Assembly of Revolutionary Artists of Oaxaca, ASARO), working collectively and anonymously. ASARO distributed their works in the streets and on the walls of the city, organizing events and applying their political messages in sophisticated and sometimes humorous images. (Smaller street art groups also formed in response to the political crisis in Oaxaca, among them, ArteJaguar, StencilZone, and MCO Stencil, and although ASARO was the largest and most visible of these, it is sometimes difficult to distinguish the works of these groups from ASARO's). During the uprising in 2006, they launched into a vibrant phase of political art production, and became more united as the situation became more dire. On the first day of November 2006, surrounded by federal police, ASARO made a radicalized version of a traditional *tapete*, the sand paintings often created during the Days of the Dead, in the center of the city. According to Yeska, one of the artists of ASARO, "It was during the meetings and preparations for Day of the Dead that we started working together in a more united and organized way. . . . We shared the idea that assemblies are a good way to organize. The movement produced so many mixed feelings: tragedy with joy, laughter with tears, order with chaos. The capacity for creativity was enormous and the arts were flourishing. We thought about freedom. We broke away from traditional rules and impositions and we found out about the liberating power of art. We experimented with new materials and forms of art, creating images to raise consciousness. . . . That was when I began to understand what I now believe is truly the meaning of art: making people more sensitive, raising consciousness, and creating new spaces for artistic expression" (Denham, 185–87).

However, the situation in Oaxaca deteriorated in the face of the governor's refusal to negotiate or compromise, and with increasingly

aggressive actions by police and paramilitary forces. During the violence at least eighteen people were killed and many activists were arrested. On November 14 the popular movement was suppressed as military and federal police invaded Oaxaca, attacking the city with tear gas, armored tanks, and helicopters. Oaxaca returned to an uneasy quiet, although to this day there remain an unknown number of political prisoners and "disappeared" whose fates are still unknown. Tensions continue to simmer below the surface.

Meanwhile, even after the end of the popular uprising, ASARO continued to work actively in Oaxaca, painting stencils on the walls of the city and exhibiting their work. They also gained international recognition, with exhibitions of their woodblock prints in Houston, Los Angeles, New York, Oakland (California), Madison (Wisconsin), and Kutztown (Pennsylvania). The Kutztown University's exhibition is currently traveling, to Chicago, North Carolina, and Pennsylvania (McCloskey, 2010). Other exhibitions have been held in such venues as a coffee shop in Seattle and a barn in Ontario. The book *Mexico Stencil Propa* contains many of their images, and their work, as well as that of other Oaxacan street artists, has a strong presence on the Internet, both in their own MySpace page and the photographs published online by visitors to the city. ASARO also held exhibitions in Oaxaca. In February 2007 the Instituto de Artes Gráficas, under the leadership of artist Francisco Toledo, sponsored *Graffiteros al Paredón*, inviting the artists to use the walls of IAGO to showcase their work. According to the museum, "IAGO has decided, on its own, to be the cultural space where these forms of expression can take place, considering that during the course of Mexican history graphic art has served as a means of expression of the longings, desires and aversions of a specific social sector." These untitled, anonymous images demonstrated the skill and inventiveness of Oaxacan street artists. In the safe, cloistered environment of the museum such images as the untitled, multicolored stencil (fig. 13) depicted the harsh political situation outside in the world, and conferred a legitimacy to the art forms used in the street.

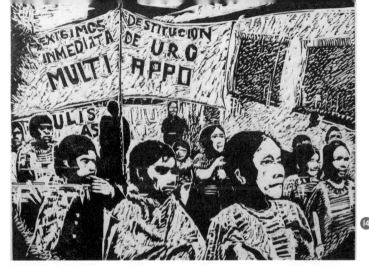

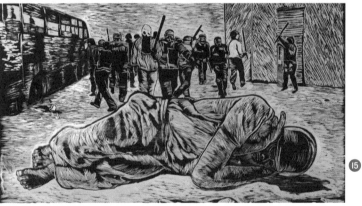

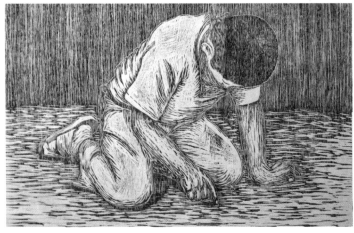

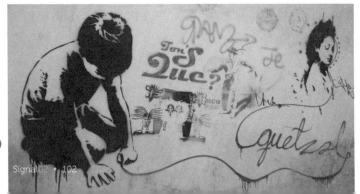

In the autumn of 2007, a year after the popular movement was defeated, ASARO held an exhibition of their woodcuts at the Escuela de Bellas Artes in Oaxaca. They used their prints as posters on the walls of the city to advertise the show, so that the streets became an extension of the gallery. A publicity poster of helicopters with calaveras (fig. 2) was a startling reminder of the events that had occurred during the siege of the city, as well as a look back to the TGP and Posada. A woodcut of indigenous women demonstrating told of the broad base of support APPO has among the many cultures of Oaxaca (fig. 14); another print depicted the murder of a protester (fig. 15); and another employed a surrealistic style to portray the governor (nicknamed URO) as a monstrous, skeletal bird, attacking a skeleton arm and fist with a hammer (fig. 16).

In ASARO's studio in Oaxaca the artists used computers to project their drawings on the wall and the group painted large-scale images, some of which incorporate graphic techniques. ASARO also sold their woodblock prints and paintings outside the Cathedral of Oaxaca; these paintings, created anonymously by members of the group, reflected the complexities of the situation in Oaxaca. They called for the release of political prisoners and those who have disappeared, they announced demonstrations and meetings, or they demanded the resignation of Ulises Ruiz Ortiz. An untitled painting (fig. 17) depicts a family that could have fought in the Revolution, with the exception of the headset that refers directly to APPO's control of local radio and television stations in 2006.

A woodcut print of a small boy playing in the dust (fig. 18), echoed both a wall stencil of a boy who draws an enigmatic line through a cluster of graffiti (fig. 19) and an enigmatic poster with the face of another child, surrounded by the word "ASARO" (fig. 20). A graffiti Zapata stared out at passersby (fig. 21), but now, along with his feverish gaze, he had a mohawk, a scar and an earring as symbols of rebellion. In a painting using the same image of Zapata, a slogan called for the release of political prisoners (fig. 23). A more conventional Zapata appeared on a wall near Santo Domingo church, this time with Benito Juárez, Zapotec president of Mexico from Oaxaca, on his hat, a stencil within a stencil (fig.

22). Another stencil of Juárez (fig. 25) was strikingly similar to the iconic image Méndez made seventy years earlier for a demonstration in Mexico City (fig. 26). Stencil images also portrayed the strength and determination of the Oaxacan people, including women and children (fig. 24). On the back wall of the Cathedral each day brought a new set of images, such as the Virgin of Guadalupe wearing a red bandana on her face (fig. 27), by implication allying herself with APPO, or images of fierce riot police in full attack mode, their hands and feet dripping blood (fig. 28).

The woodcut prints and paintings paralleled the stencils and posters that appeared on the walls of the center of Oaxaca from one day to the next, that were covered over by other posters and other graffiti, and were painted over or torn off in futile attempts to clean their messages off the walls. More graffiti stencils, prints, and paintings sprang up in the place of those that were removed, creating a vibrant, changing graphic environment.

It is remarkable in how many ways, over fifty years later, ASARO was connected in spirit and in style to the Taller de Gráfica Popular, a continuity unique to Mexican art and politics. ASARO readily acknowledged the influence of the TGP, and like the works of Méndez and other members of the TGP, ASARO's images referred both to Mexican history and the present. Like the TGP, ASARO was a collective, working for the benefit of the people, making fugitive, ephemeral work as a reaction to violence, corruption, and injustice. During the uprising and its aftermath, the artists of Oaxaca were like their predecessors in other ways too: their work was directly tied to social purposes and immediate events; they participated in a direct democracy of the most dynamic kind, using the walls of public places to convey urgent messages to a wide public; they thought of the artist as an active agent of social change; they were provocative, confrontational, and audacious in their imagery; and they saw art as inseparable from life, politics, and social engagement. Unlike the TGP, which responded to both Mexican and international situations, ASARO was directly involved primarily in a local political crisis, albeit one with great international significance, and though they did understand these

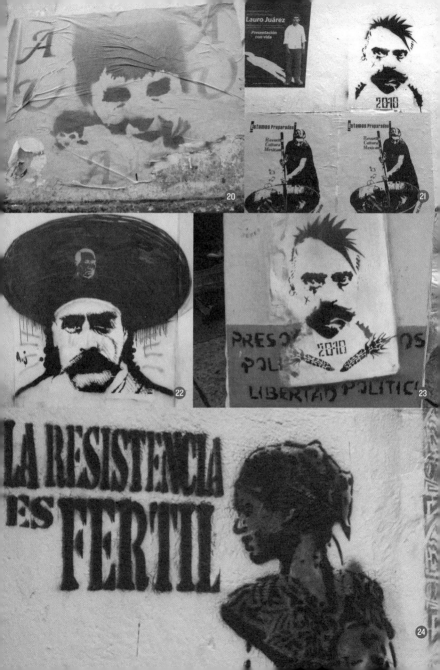

HOMENAJE
A
BENITO JUAREZ
FORJADOR DE LA NACION
VIERNES 18 DE JULIO, a las 6 horas, en el Homicidio de la Alameda, honrada para recibir ¡ACUDA USTED!
así su memoria a expresar la voluntad del pueblo mexicano, para
mantener el respeto a la Constitución y a las Leyes de Reforma.
C. T. M. **TALLER DE GRAFICA POPULAR** DIARIO "EL POPULAR"

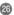

issues in a global context, their focus was almost exclusively on Oaxaca. In terms of their identity as artists, members of the TGP and ASARO preferred to be in the background, though the TGP did not go as far as ASARO; the artists of ASARO were (and continue to be) completely anonymous and did not sign their work. Like the TGP (and, in fact, all committed artists' groups), members of ASARO faced complex questions: how to support themselves, how to maintain the organization while avoiding commercialization, how to

avoid arrest for their political activities, how to interact with the art market, and how to deal with sudden fame.

This was the situation in Oaxaca from 2006 to about 2008. Since 2008, however, the quantity of graffiti has diminished considerably. Recent efforts to eradicate the presence of graffiti in the historic center have been successful. The so-called Gray Brigades (*Brigadas Grises*) cover all graffiti with gray paint on a daily basis (fig. 29), and tear down posters as fast as they are put up. The economic crisis and political

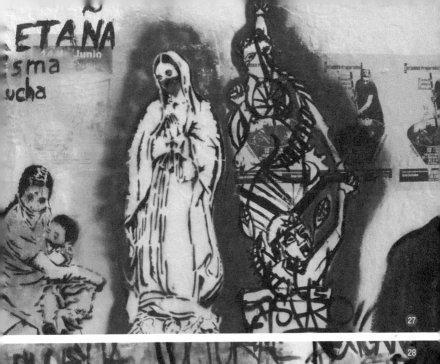

unrest resulted in a decline of tourism in Oaxaca, and the market for prints and posters ended. ASARO closed the gallery they started in 2008, moved their headquarters to a less expensive and less central neighborhood, and diminished their activities. Shows in galleries have to some extent replaced the spontaneous application of stencils and prints on walls. Thus one can talk about the extraordinary flowering of graphic protest art as an impressive phenomenon linked to the cultural and political resistance movement in Oaxaca, a movement that has been defeated, perhaps temporarily.

Though there is still great interest in their work, the dynamic political situation that informed their practice has passed, and therefore does not provide a viable site for the art itself. As artist Kevin McCloskey recently put it, "that collection of 2006 and 2007 woodblock prints already seems like a time-capsule from another era." This is not to say that ASARO is gone entirely; their prints and graffiti continue to inspire and impress as a valuable body of graphic art, created, as Méndez put it almost sixty years ago, "in the service of the people." **S**

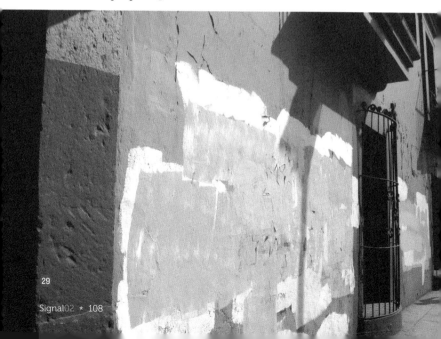

Bibliography

Brown, Pat. "The Art of Revolution: Social Resistance in Oaxaca, Mexico." *Commonsense 2: A Journal of Progressive Thought*, December 2007.

Caplow, Deborah. *Leopoldo Méndez: Revolutionary Art and the Mexican Print*. Austin: University of Texas Press, 2007.

Denham, Diana, and CASA Collective. *Teaching Rebellion: Stories from the Grassroots Mobilization in Oaxaca*. Oakland: PM Press, 2008.

Editorial RM, ed. *Mexico: Stencil: Propa*. Mexico City: RM, 2008.

Gibler, John. *Mexico Unconquered: Chronicles of Power and Revolt*. San Francisco: City Lights Books, 2009.

Ittman, John, ed. *Mexico and Modern Printmaking: A Revolution in the Graphic Arts*. Philadelphia and New Haven: Philadelphia Art Museum/Yale University Press, 2007.

Kiamco, Gerlaine. "Delinquent or Citizen: Graffiti Artists in Oaxaca, Oaxaca." http://www.casacollective.org/story/analysis/delinquent-or-citizen-graffiti-artists-oaxaca-oaxaca.

McCloskey, Kevin. "Hasta Cosas Cambian: Until Things Change." *Commonsense 2: A Journal of Progressive Thought*, August 2008.

McCloskey, Kevin. "Mexico 2010 and an Update on ASARO of Oaxaca." *Commonsense 2: A Journal of Progressive Thought*, February 2010.

Meyer, Hannes, ed. *TGP México: El Taller de Gráfica Popular: doce años de obra artística colectiva/The Workshop for Popular Graphic Art: A Record of Twelve Years of Collective Work* (Mexico City: La Estampa Mexicana, 1949).

Prignitz-Poda, Helga. *El Taller de Gráfica Popular en México, 1937–1977* (Mexico City: INBA-CENIDIAP, 1992).

Tukey, Aaron. "War of the Walls: Rebellion and Graphic Art in Oaxaca." http://nimla.com/.

Velez Ascencio, Octavio. "Creadores llevan su arte callejero al recinto de Oaxaca: El IAGO abre sus puertas a Graffiteros al paredón: Exponen su repudio a agresiones de Ulises Ruiz y la PFP," *La Jornada*, (Mexico City) February 4, 2007.

Websites

http://commonsense2.com

http://www.myspace.com/asaroaxaca

http://www.myspace.com/losartejaguar

http://colectivozape.blogspot.com/

http://web.mac.com/dfteitel/iWeb/ASAR-O/Home.html

http://www.fotolog.com/bembaklan

http://www.graphicwitness.org/ineye/index2.htm

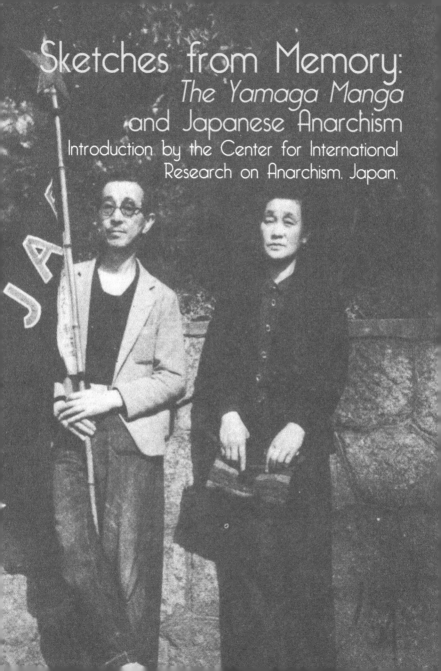

Sketches from Memory:
The Yamaga Manga and Japanese Anarchism
Introduction by the Center for International Research on Anarchism, Japan.

Taiji Yamaga was a seminal figure in the early anarchist movement in Japan. A printer and propagandist, Yamaga was involved in international labor, anti-militarist, and anti-fascist struggles. He traveled extensively and worked with some of the most well known figures of Japanese anarchism, including Sakae Ōsugi, the Bluestocking Society, and Noe Itō. Yamaga was also an avid Esperantist who produced translations, collaborated, and corresponded with hundreds of comrades abroad. In his later years Yamaga was a crucial figure in the sharing of stories about anarchist history in Japan. *The Yamaga Manga*, printed here, is a visual autobiography drawn by Yamaga towards the end of his life.

Taiji Yamaga was born into a printing family in 1892 in Kyoto. His father, Zenbei, had established the first movable-type printing press in the area. At the age of fifteen, Yamaga moved to Tokyo, where he studied Esperanto with the historian and noted Esperantist Katsumi Kuroita (1874–1946). Kuroita was the founder of the Japan Esperanto Society (Japana Esperantista Asocio), which had an office where Yamaga lived. At the age of sixteen, Yamaga served as the secretary of the Japan Esperanto Society.

Soon after twelve anarchists and socialists were executed in the High Treason Incident of 1911, Yamaga borrowed a coworker's copy of Peter Kropotkin's *Conquest of Bread*, which greatly influenced him. Later that year Yamaga was introduced to the well-known anarchist Sakae Ōsugi (1885–1923). Upon Ōsugi's recommendation, Yamaga went to Shanghai in March of 1914 to meet Liu Shifu. Yamaga wrote articles in Esperanto for *The People's Voice* (La Voco de la Popolo), a newspaper with content in both Chinese and Esperanto published by Shifu's underground People's Voice Press.

Yamaga returned to Japan after nine months to help with the publication of *The People's Newspaper* (Heimin Shimbun). Launched in 1903 by Toshihiko Sakai and Shūsui Kōtoku, *The People's Newspaper* was arguably the leading radical newspaper in early-twentieth-century Japan. Yamaga also continued to publish anarchist books in spite of fierce state repression. In 1915, along with Tadashi Aisaka and Shinroku Momose, he published

Kropotkin's *An Appeal to the Young*.

In 1916 while visiting the home of radical thinker and fellow Esperantist Ikki Kita, Yamaga met Mika Shigehara (1896–1996), an apprentice in the Kita household. They married and continued to live together as partners until Yamaga's death in 1970. Yamaga's older brother who had been managing the family business died in 1918, and Yamaga moved back to Kyoto to resurrect Tenrindō, the family print shop. Yamaga used Tenrindô to publish criminalized and banned materials, such as books by Paul Berthelot and documents related to the High Treason Incident.

In 1922, he visited Shanghai again, this time to join the Anarchist Federation. He was the only person from Japan to do so. He returned to China later that year to obtain a passport for Sakae Ōsugi, who was attempting to travel to Berlin for the International Workers' Association congress. With a counterfeit

The cover of *The Yamaga Manga*.

Translation: "Sketches from Memory. The golden 'ORO'-like 'Memoro' memories—to me it is 'MEM'; to others perhaps nothing. From my experiences, I can carve out the memories that are worthy of gold. To myself, I call them 'mem-oro'."

[Translators' note: in Esperanto, 'mem' means 'self,' 'oro' means 'gold,' and 'memoro' means 'memory'.]

passport that identified him as a Chinese student, Ōsugi was able to travel to Europe, where he was arrested and extradited to Japan after attending a May Day rally in Paris in 1923. In September, the Great Kanto Earthquake struck Japan. Police and vigilantes killed thousands of Koreans and Chinese during the days of martial law after the quake, and military police beat Ōsugi, Noe Itō, and Munekazu Tachibana to death. Yamaga would inform the world of these killings in a communiqué written in Esperanto.

In 1927, Yamaga's translations of international movement news and serialized Esperanto lessons appeared in the fifth volume of *Labor Movements* (Rōdō Undo), an anarchist journal published by Kenji Kondō, partner of Magara Sakai (Kondō), a founding member of the anticapitalist and radical feminist Red Wave Society (Sekirankai). In August of that same year, Yamaga was appointed to teach Esperanto as a faculty lecturer at the newly established National Labor University in Shanghai. Yamaga returned to Japan in December, where he resumed work on underground publications.

Yamaga moved frequently for a six-year period beginning in 1939. He lived in Shanghai, Kaohsiung, Taipei, and Manila. While in Manila, he learned Tagalog and compiled a Japanese-Tagalog dictionary. In 1946, he returned to Kyoto and began publishing an Esperanto edition of *The People's Newspaper.*

Yamaga attended the tenth international meeting of the War Resisters' International in India in 1960. Shortly thereafter, Yamaga collapsed from a stroke. In 1962 he began writing his memoirs, called *The Twilight Journal. The Yamaga Manga* is an illustrated journal he drew to help him organize his memories while he wrote.

The Yamaga Manga is a precious record of the life, personality, and activism of this unsung hero, who accomplished much behind the scenes, presented to us as vivid illustrations. **⑤**

Introduction translated by Adrienne Hurley.
Manga translations by Christopher Byland, Eva Gjerde, Sarasa Mizuno, and Ami Yoshimi.

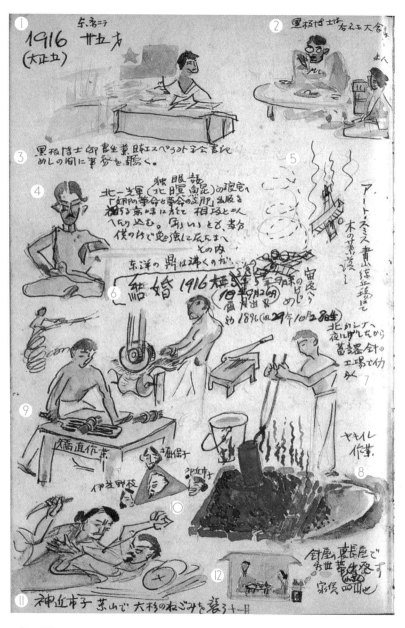

1. 1916 (5th year of Taishō), Tokyo, age twenty-five.

2. Dr. Kuroita's House a.k.a. Japan Esperanto. Asking about business matters while eating.

3. Discussing important matters while eating at Professor Kuroita's House, a.k.a. the Japan Esperanto Society. Professor Kuroita was a notorious gourmand. [Pictured from left to right: Yamaga, Kuroita, and Kuroita's wife.]

4. With the intention of celebrating the publication of China's Revolution and Revolutionary China, Aisaka and I visited Kita Ikki, the One-Eyed Monster. "Yes, come study at my place," he said. "Before long chaos will embroil East Asia. . ."

5. Art Smith entertains the crowd at the Aoyama parade grounds. He maneuvers into a free fall and then begins the somersault. [Art Smith was an early American aviator and stunt pilot who performed in East Asia in 1916 and 1917.]

6. I married Mika (born October 28, 1896, or Meiji 29) in the end of September of 1916 or Taishō 5th year. [A later correction in brown ink indicates "10th year September 26th."]

7. After Kita skipped out to China, I worked at a factory that made gramophone needles.

8. Tempering process.

9. Straightening process [written on the work bench].

10. Noe Itō, Horii Yasuko, Kamichika Ichiko [depicted in the "love triangle" with Sakae Ōsugi in the middle. Ōsugi, a prominent Japanese anarchist and proponent of free love, was married to Horii Yasuko. He engaged in open affairs with Kamichika Ichiko and later with Noe Itô].

11. Kamichika Ichiko attacked Ōsugi while he slept in November at Hayama.

12. (Ko-san) left our temporary household in the shack behind the needle factory. Rent was 400.

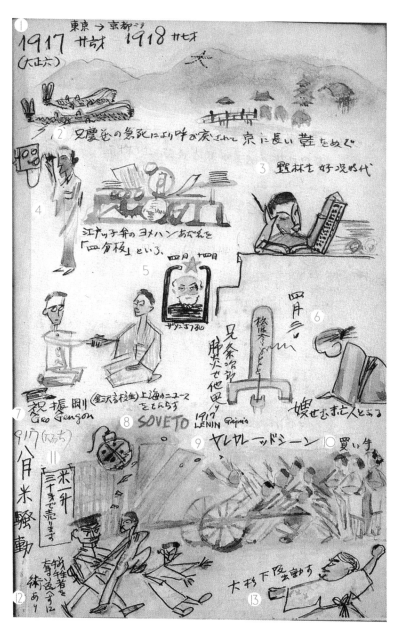

1. From Tokyo → Kyoto in 1917 (6th year of Taishō); 1918.

2. I had to wrap things up and head back to Kyoto when my brother Keizō unexpectedly died. I was twenty-seven at the time.

3. High times for Tenrindō. [Tenrindō was the Yamaga family's printing press business.]

4. Mika, with her strong downtown Tokyo accent, earned the nickname Gravel-Mouth.

5. April 14th. Death of [Ludwig] Zamenhof [founder of Esperanto].

6. Tadajō Jirō died of pneumonia on April 3rd, leaving behind a grieving widow.

7. Geo Gengon, an exchange student from China studying at Kanazawa High School, informed me about the news concerning our comrades in Shanghai in fluent Esperanto.

8. Soveto 1917 Lenin. [This appears to commemorate the Petrograd Soviet.]

9. Attack! Attack! Boom!

10. Buyer.

11. 1917 August Rice Riots. Buyers call out, "Let's go," "Give them the old heave-ho!," and "We will sell 1800 cc of rice for 30 sen." [Translators' note: The crowd demanding to have the price of rice lowered rushes on the rice shop. They make a poster indicating the price at which they will sell the rice.]

12. Here's a good way to rescue someone who is about to be captured by the police.

13. Ōsugi summoned to Osaka.

1. 1919 (Taishō 8th Year) in Kyoto at the age of twenty-eight.

2. The Secret Publication Incident.

3. The synopsis of Kropotkin's *The Conquest of Bread*.

4. *Syndicalism*, 1919 Edition. The General Strike Union.

5. Kôtoku Shusui is charged for plotting a scheme to assassinate the Emperor of the time and to trigger a social revolution. . . Prosecutor Nakata Kajita silently skipped over the word when he read these lines at court.

6. *The Bell of the Commoners*
 The splendid revelation of our time

7. Kōtoku Shusui: The Imprisonment Record. [Kōtoku Shusui was a prominent anarchist writer and translator. Shusui was executed in 1911 as part of the High Treason Incident. Yamaga tried to publish a letter sent from imprisoned Kōtoku Shuusui addressed to three lawyers, Imamura Rikisaburō, Hanai Takuzō, Isobe Shirō, but he failed to print a single copy because spies began to investigate his relatives. Afterwards, he secretly published *The Conquest of Bread*, *Syndicalism*, and *The Bell of the Commoners*.]

8. *The Christian Annihilation Theory* publication by Takashima Beihō.

9. February 19th, night. Information received.

10. Packing bare essentials.

11. Secret publications hidden by the hands of Ueda Aliyoshi in Gion Hanamaki District.

12. 20th night, at the Gojyō Police Station.

13. Prosecutor Nakata Kajita: "We'll have a problem if you don't tell us where you hid the books."

14. "Anarchists don't confess. Torture us if you think we're joking."

1. Kyoto Prison.

2. Accomplices.

3. Ueda Ariyoshi.

4. Uehara Tomosada. [Yamaga corrects his earlier misspelling here.]

5. Rokudai Shinpō Publishing Factory Manager. [Rokudai Shinpō was the factory which published Yamaga's secret publication.]

6. The man asked by Ueda to hide the books.

7. Cooks.

8. Kyoto Prison's cells for pending cases remained the same as jails from back in the old days.

1. 1920 (Taishō 9th Year), age twenty-nine.

2. Kyoto → Osaka → Kyoto.

3. Off-limits from the public.

4. "This is the original copy of the book the defendant released, *The Conquest of Bread*, or in French called *La Conquête du Pain*. This was brought from the university library. The world would be a paradise if it were run this way, what is the problem, the defendant is innocent."

5. Mr. Katsumoto, the lawyer.

6. Osaka. Wakamatsu, detention house.

7. Transferred to Osaka Court for the appeal.

8. The first May Day, May 2nd, 5,000 people gathered in Ueno in Tokyo.

9. The community cell I was mistakenly put in transformed into an Anarchist dōjō [training ground].

10. Gambling, three years.

11. Wakayama's Tsuji Yasushi, ten years for sedition. [Tsuji Yasushi was a man Yamaga met when he was accidentally put into the community cell.]

12. Rice Incident; Arson, Life Sentence. Osaka Araki.

13. Murder, eight years.

1. Results of the appeal and invalidation. Transferred to Osaka Horikawa Prison. "Sentenced to three years in prison."

2. "The seven on the left, enter the bath!"

3. Horikawa Prison reconstruction. Due to relocation, transferred back to Kyoto Prison.

4. The request to work is approved.

5. Envelope making, 2,000 to be made in a single day, eight-hour shift.

6. For each completed assignment, an additional once-per-week bathing permission is granted. Reading, writing, exercise within the cell is permitted outside of working hours.

7. A man called Akashi Norimasa apparently claimed that criminals and sleeping men are innocent and ordered for the bed linens to be indigo blue.

1. 1921 (10th year of Taishō), age thirty.

2. Kyoto → Manshu → Shanghai → Tokyo.

3. Warden.

4. "You on the right! I approve your parole."

5. Chaplain.

6. Deposit 100 yen.

7. [This is most likely a note Yamaga made that isn't related to 1921. The meaning is unclear.]

8. I got married in the 10th year of Taishō on September 26th. [See the correction Yamaga made on the first page of the manga. It appears he met Mika in 1916 and that they married in 1921.]

9. I didn't know that Kropotkin died in February.

10. I commuted to work at Tenrindō from here.

11. The Tsuchiguchi residence in Yamanashi prefecture in front of a graveyard.

12. [A train that connects the cities of Kyoto and Ōtsu.]

13. February 8th, Kropotkin dies.

14. Yoshida drops in to give advice on going to Russia.

15. Mr. Wada Hisashi also dropped by to convince me to head to Tokyo.

16. Sanou Ichirou was repatriated from Shanghai and placed under house arrest, but he discussed escaping again. [Much of this passage is faint and illegible. Sanou conveyed his plans to Yamaga during a visit. This inspired Yamaga to return to Tokyo with Mika and support Ōsugi and the Labor Movement Association.]

17. Escaped out of Yamanashi with the aid of Sasai.

18. I did my best to maintain a strict vegetarian diet for a full year.

19. Ōsugi and company published *Rōdō Undo* (The Labor Movement) in December.

1. July 1922, to Shanghai.

2. Headed to Hojo Nakamura's home in Manchuria. I went to Shanghai, leaving Mika behind.

3. I arrived in Shanghai with Pinkō, but Tokuda Kyuuichi returned. [Yoshida Kazu, a.k.a. Pinkō or Pin, had been to Moscow after the revolution. Kazu is written with the character for the number one. "Pin" is another reading for that character, hence the nickname. Tokuda Kyuuichi was the first head of the Japanese Communist Party.]

4. Lieutenant Colonel Iimori arrives.

5. We collapsed in the Nagata Hospital, run by Kita Ikki's friends, right across the street from Iimori Masayoshi's hotel. Across the street was Iimori's Hotel. Katakana Wireless Communication. Pin borrowed money from Iimori to run away back home.

6. Uchida Ryohei's friends.

7. Yuhuang Hotel.

8. Iimori.

9. IS THERE A SPY?

10. I also joined the United Front. [The Daitōdō or United Front was a secret society that militated for freedom and peace and supported comrades who were endangered.] I joined the Anarchist Federation (AF). Signed and was initiated.

11. Introducing Pei-Kong, an old friend. Wong Lin Chuan was off to the United States. Also met with Ho Bo-fu and Li Tokuken.

12. Muraki Gen.

13. Ōsugi.

14. As for the AF's pledge . . . oath. Ōsugi says, "It is too religious."

15. Lin Chuan leaves for Clark University.

16. He tried standing behind the case, but. . .

17. Kuwahara Ren.

1. Taishō 11th Year, 1922. Age thirty-one, December.

2. Tokyo → Beijing → Shanghai.

3. Letterpress Printing Branch.

4. With the support of Matsuda-kun, an old friend back from the Tsukiji Printing Press, I grasped the stick once more.

5. Mountain-pass lodgings, Hongō-Shinmei-chō hideout. [Translator's note: Yamaga built a hideout in Hongō-Shinmei-chō under the name of "mountain-pass lodgings."]

6. Hongō-Sendagi-chō. Katsura Mochizuki Residence.

7. Police. Hongō Akebono-chō.

8. Spy hut.

9. Labor Movement Society Headquarters. Ōsugi Residence.

10. Short-cut.

11. The "?" person—Shirayama Takeshi—comes from China as an envoy. Permanently assumes the name Ō Shikei. Minister for Business for the Reformed Government of the Republic of China.

12. Beijing.

13. Tianjin → Fengtian [present day Shenyang] → Jingfeng railway [present day Jingha Railway].

14. Shanghai.

15. Busan.

16. Ōsugi heads to Beijing to get a Chinese passport after receiving an invitation to go to the International Congress of Anarchists in Berlin.

17. One day in November in Fengtian, my rubber boots froze and I couldn't walk. I barged into an unknown house and got some hot water to wash up. So much for vegetarianism. . . [Yamaga is a vegetarian, and therefore does not wear leather boots. However, the freezing of his rubber boots forces him to stray from his vegetarian lifestyle.]

1. I hadn't seen Ero-san in a long time. ["Ero-san" refers to the Russian anarchist Vasili Eroshenko]

2. Russian literature student at Beijing University.

3. Zhou Zuoren's older brother, Zhou Shuren.

4. "If you remember me?"

5. Gate of China in Beijing.

6. National University of Beijing—Sinology.

7. Ero introduced me to Chen Kun-shan.

8. Chen Kun-shan [Chen Kun-shan was an Esperantist and a well-known member of the Anarchist student society at the time.]

9. Wang Luyan [one of Chen Kun-shan's roommates and an Esperantist]

10. Groaning loudly on the bamboo bed.

11. National Customs Daily Report

12. Requested a passport from Jing Meijiu, using references from Kun-shan.

13. President of National Customs Daily Report, Jing Meijiu.

14. Type need to be washed with hot water, or they will freeze.

15. Yang [fortune telling stand].

16. Lamb meat soup.

17. People shitting.

18. People being bitten by lice.

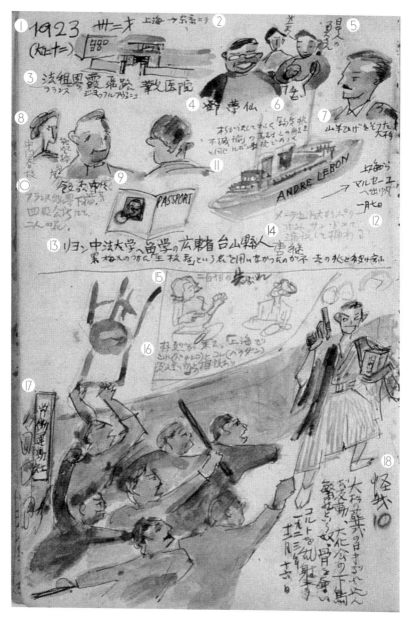

1. 1923, 12th year of Taishō, age thirty-two.

2. Shanghai →Tokyo.

3. Av. Joffre, French Concession in Shanghai Hua Guang Clinic.

4. Deng Meng Xian.

5. Japanese wife.

6. Little 'un.

7. Ōsugi after shaving off his goatee.

8. Nakakado (or Chūmon) Harune.

9. Iimori Chūsa. [Iimori was a commander of the navy and a follower of the Ōmoto religious sect. He was called the "Red Commander." He followed Tolstoy and had friendly relations with both anarchists and socialists. It is believed that Nakakado, like Iimori, was one of Eroshenko's colleagues (or pupil?). However, not much detail is known.]

10. At an inn in the French Concession of Shanghai. At Si Ming Gong Suo. "Flower of Two."

11. The name of the ship is the same name as that of the author of *La Naissance et l'evanouissement de la matiere*, Andre Lebon.

12. Depart Shanghai for Marseille on January 7th.

13. A student from Taishan county, Guangdong Province on exchange at The Sino-French Institute of Lyon, in the name of Tang Ji. He says that the fact he did not use the alias "Ō Shōju" given to him by Jing Meijiu was an ominous sign. [Ōsugi used the name "Tang Ji" and was supposedly a "student from Taishan county, Guangdong Province on exchange at the Sino-French Institute of Lyon" in the fake passport he obtained in order to go to France.]

14. Ōsugi is arrested after making a speech during the May Day Protests at St. Denis, the suburbs of Paris.

15. Signs of the 210th day (day of storm).

16. Park Yeol comes over and we have a discussion on whether or not you can buy this (pachinko) and this (bombs) in Shanghai.

17. The Labor Movement Society.

18. Injury 10. A reactionary named Shimotori Shigezō from the right-wing Taikakai slips into Ōsugi's funeral. He steals Ōsugi's bones and fires his colt sporadically.

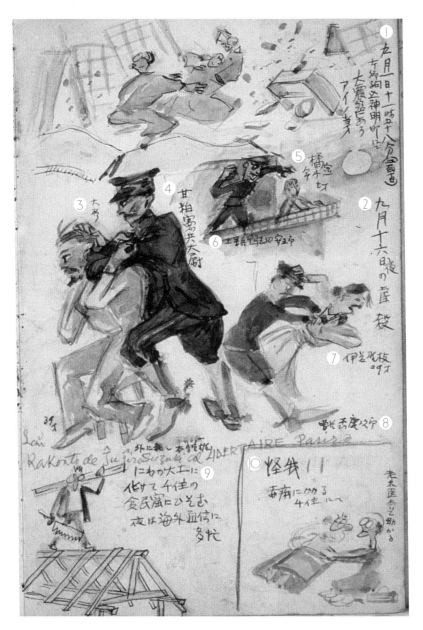

1. September 1st at 11:58 a.m. (the 210th day) at Shinmei-chō, the Great Kantō Earthquake struck.

2. September 16th, the Massacre of the Night.

3. Ōsugi, age thirty-nine.

4. Captain Amakasu of the Kenpeitai (military police).

5. Tachibana Munekazu, seven years old.

6. Private First Class Kamoshida Yasugorō.

7. Noe Itō, twenty-nine years old.

8. Master Sergeant Mori Kōjirō.

9. I go into hiding in the slums of Senju by disguising myself as a makeshift carpenter. During nights I am buried in work with international correspondence.

10. Injury 11: Contracted dysentery in Senju. I recover thanks to an old, acclaimed doctor.

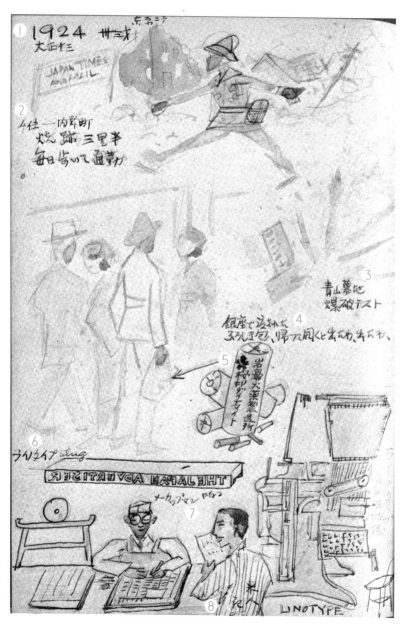

1924
大正十三
東京にて

JAPAN TIMES
AND MAIL

4住一内幸町
焼跡 三里半
毎日歩いて通勤

青山墓地
爆破テスト

銀座で渡された
ふろしき包、帰って開くと出た出た、

岩鼻火薬製造所
桜印ダイナマイト

ライノタイプ slug

THE JAPAN ADVERTISER

メーカップマンになっ

LINOTYPE

1. 1924 (13th year of Taishō), age thirty-three, Tokyo.

2. Senju Uchisaiwai-chō. Everyday I commute to work by walking among the debris from the fire for fourteen kilometers.

3. Aoyama Cemetery, explosive testing.

4. After opening a parcel I received in Ginza, here they are, here they are:

5. Iwabana Gunfire Factory: Sakura Print dynamite.

6. Linotype slug.

7. I become the editor of printing.

8. American.

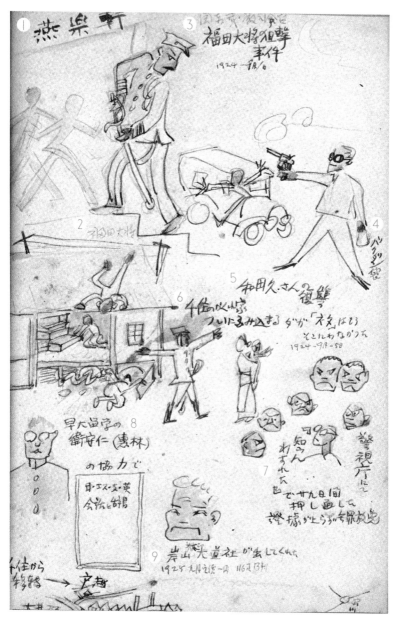

1. Party Hall.

2. General Fukuda.

3. September 1st, 1924: General Fukuda assassination attempt.

4. Bomb bag.

5. Mr. Wada Kyu's revenge.

6. September 5th, 1924: My secret hideout in Senju is finally discovered and raided. However, the "materials" are no longer there.

7. At the metropolitan police department. I get through the twenty-nine days of questioning with the phrases "I don't know, I forgot." I was absolved due to lack of evidence.

8. Wrote the *Japanese–Esperanto–Chinese–English Conversation and Dictionary* in collaboration with "Wei An Ren" an exchange student from Waseda.

9. Kishigami Ōdōsha Company released it.

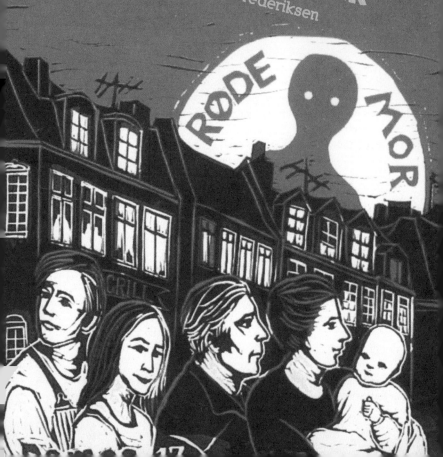

A HEART OF
CONCRETE THROUGH
FIRE AND WATER

Kasper Opstrup Frederiksen

Røde Mor (Red Mother) was a Danish cultural collective fueled by the rupture of the 1960s. From 1969 to 1978 they rode the political and cultural wave of mass surrealist outbreaks and the New Left, starting out as a graphic workshop and evolving into a band, a circus, and finally a fund for political art projects. The beginnings of the group can be found in the late 1960s where Troels Trier, Ole Finding, John Ravn, Yukari Ochiaia, and Dea Trier Mørch all exhibited art as individuals in the Copenhagen and Aarhus areas of Denmark. In 1969, they presented themselves as an art collective with a manifesto in the form of poetry:

> Red Mother is the revolution's mother
> The mother of the oppressed, the weak and the orphans
> Red Mother waits for you, won't forget you and keeps the
> food warm
> Red Mother is a wild and ferocious lioness
> Red Mother walks with an olive branch in its beak
> Red Mother is a black sheep and, also, a red flag.

At their openings, Troels Trier, Ole Thilo, and Lars Trier would often play music, and this activity soon grew into Røde Mor's Rock Show which released a string of recordings of protest songs and satire between 1970 and 1978. Early on, the collective also wrote a political manifesto aligning itself with the proletarian class struggle. This manifesto became the common platform for all the group's activities and was continually reworked and rewritten throughout the years as the group evolved. Each year, the collective published a catalogue with news about their activities and production. In *Catalogue no. 5*, 1974, the manifesto reads as follows:

Art and class struggle have seemingly nothing to do with each other. But in reality, art and class are inseparable concepts.

In earlier societies, each class had its art. The oppressors and the oppressed each had their art which gave them identity. But art history tells us only about the ruling class's art since it is the dominant power that writes history. When our society seems to have only one art—bourgeois art—it is because the bourgeoisie has taken monopoly over even art and culture. Highbrow art is being produced for the bourgeoisie while the workers are kept down with entertainment and advertising. Thus, the culture monopoly works as a means to consolidate bourgeois power and the spread of bourgeois ideology in the working class. The bourgeois artist participates whether he likes it or not and whether he is conscious of it or not—in this repression. Contrary to this, we will make our art available to the working class and help to create a political, proletarian art. By political art we mean an art that describes the social conditions and takes political positions. By proletarian art, we understand an art that takes a—in Marxist terms—proletarian standpoint. The political, proletarian artist's job is to lead the class struggle in the cultural field. We must prevent the spread of the dominant ideology in the classes facing Capital. We will create an art that helps to give the working class identity. An art that is a weapon of class struggle.[1]

Thus, what made the group distinctive was its political commitment to collective and collaborative working practices. The collective process was intended as a critique of individualism in the arts, the art market's focus on celebrity, and on individual artists who produced work to be sold and collected. Also, it was an attempt at creating a fertile cultural playground where the problem-solving skills of communal production would be put to use and ideas could evolve collaboratively. The focus had to be moved from the individual producer to the mutual sharing of ideas, techniques, and the pooling of resources. In practice, the group's works evolved collectively and in collaboration with various worker movements and organizations, in an attempt to use a hands-on approach to capture what the workers actually wanted to represent.

Aesthetically, the orientation was Socialist Realism, which was then the official representative style of the Soviet Union. Their main graphic inspiration came from Vladimir Mayakovsky, Frans Masereel, and the history of the workers' movement. The aim was to exhibit the inherent contradictions and paradoxes in capitalist society. Røde Mor sought to propose a socialist solution to society's problems by uncovering the mechanisms of power using satire, the carnivalesque, and the grotesque. Often the results took the form of posters and prints depicting everyday people at work or of agit-prop, supporting various global struggles and revolts. Many of the posters consist of several images. At first, these were individual images juxtaposed, depicting a problem from many different angles and proposing possible solutions but, over the years, the posters started to work more with a narrative, becoming akin to a page from a comic book. This focus on narrative culminated in Røde Mor's last projects, which were proper graphic novels consisting of narratives of images depicting the ideologies of the working class, such as *Billedroman* (Image novel), published in 1977.

In *Catalogue no. 2*, 1971, the collective made their graphic position clear and invited people to join the struggle and do it themselves:

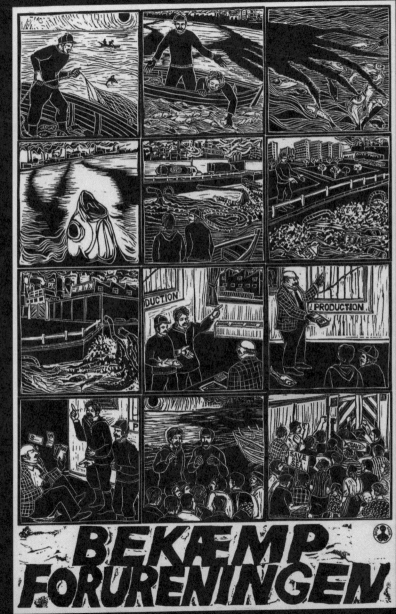

RED MOTHER has chosen to create collective images. By collective images, we not only mean things which everyone in RED MOTHER have contributed to, we also mean that the individual works have emerged from joint discussion and criticism. RED MOTHER will no longer sign and number its graphic works.

We have hitherto mostly used linoleum cuts. Linoleum is a cheap material, soft to cut and easy to press. You can make prints at home, but the finished linocut can also be used directly as a stereotype at the printer's. The coarse nature of a linoleum cut makes it suitable for agitation purposes. The clear black-and-white contrast is easy to reproduce in newspapers, magazines, books and on posters. No shades of grey are lost because they do not exist.

While working on these collective images, members of the group became inspired by the happening scenes and the cultural New Left, groups like the Yippies in the United States and the Provos in Amsterdam. This resulted in an elaborate rock show playing out satirical scenes on stage. The rock show went on the road with a repertoire of protest songs as well as general madness, mischief, and mayhem, and evolved into a proper circus with the incorporation of Clausen & Petersen's Street Circus into the collective. The band became a hit, releasing a series of popular albums, starting with 1971's *Johnny gennem ild og vand* (Johnny through fire and water) through their final live album, *Sylvesters drøm* (Sylvester's dream), in 1978. In Denmark, their best-known album is *Hjemlig Hygge* (Coziness at home) from 1976, which was broadcast on national television as a comedy show lampooning Danish

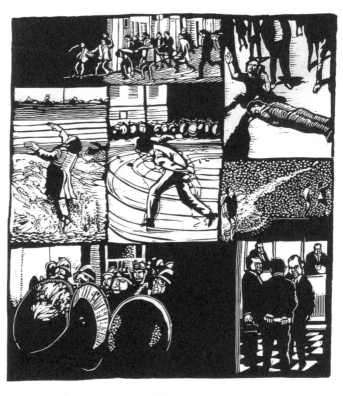

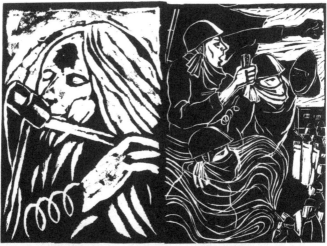

society through a gross over-identification with mainstream bourgeois values.

Due to the success of the projects and the need for more specialized skill sets, the collective split into two official groups in 1972: Røde Mors Grafikgruppe and Røde Mors Rockcirkus. Although focusing on music, the band continued as a vehicle for agit-prop since the graphics went on tour with them. The stage was seen as yet another propaganda platform where satire, buffoonery, and songs could convey antiwar and anticolonial messages as well as dreams of communist utopia. Thus, the collective's highly recognizable graphics were displayed widely in Denmark and gained a direct connection to people who would not normally frequent museums, galleries, or not-for-profit spaces.

In 1978, the collective decided to stop its cultural production. One of the members of the graphic group, Thomas Kruse, has in hindsight identified three factors to the break-up: personal, artistic, and political.[2] Personally, the members had worn each other out through intense work schedules and felt that they had become locked into fixed identities—always a position to avoid if

one's project is intended to be subversive. At the same time, the group felt the erosion in impact of its political metaphors and clichés. Politically, people had started to drift, both in their support of the Soviet branch of Marxism and due to the general crisis of the traditional left-wing party. After 1978, the remaining group members started Røde Mors Fond, a fund based on income from record sales and merchandise. The fund's aim was to contribute economically, through stipends and the like, to the continued production of political and critical art on the Danish cultural Left. It existed until 1987 and gave out its stipends and rewards each second Sunday of May on Mother's Day.

The following were members of the Graphic Group and the Rock Circus in the period from 1973–1978 and became the fund's members of the board: Erik Clausen, Peter Ingemann, Thomas Kruse, Peter Mogensen, Andreas Trier Mørch, Dea Trier Mørch, Yukari Ochiai, Leif Sylvester Petersen, Henrik Strube, and Troels Trier. Other members of the collective at different times were: Michael Boesen, Niels Brunse, Alice Faber, Dorte Fasting, Ole Finding, Tommy Flugt, Pia Funder, Per Almar Johnson, Maiken

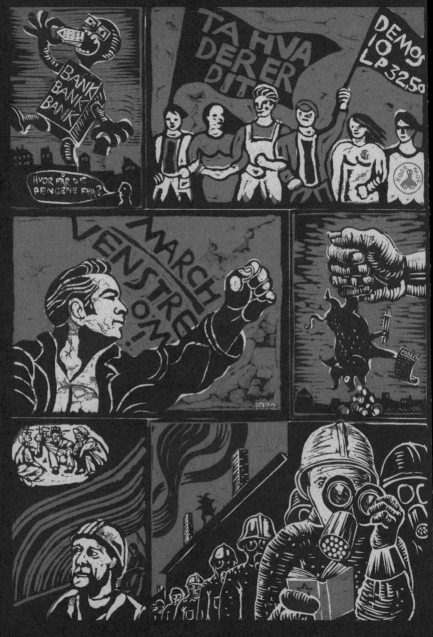

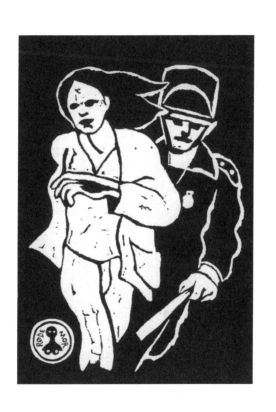

the vast majority of their distinctive linocuts and also a successful writer (her 1976 novel *Vinterbørn* [Winterborn] was translated into multiple languages and made into a film of the same name in 1978), she died of cancer in 2001 before the reunion. After the reunion in 2002, the collective published a new manifesto, *Røde Mor og de nye tider* (Red Mother and the new times):

Junker, Anne-Mette Kruse, Erling Benner Larsen, Kim Menzer, Jens Asbjørn Olesen, Anne-Marie Steen Petersen, John Ravn, Karsten Sommer, Finn Sørensen, Ole Thilo, Ann Thorsted, Jacob Trier, and Lars Trier.

In 2002, the band reunited and toured for a couple of years in support of a remastered box set of their music and an exhibition of the collective's art and design at the Royal Library in Copenhagen. Currently, they are on hiatus again even though their official website (www.rodemor.dk) promises a return in thirty years' time for a final show. The last official release was a compilation CD released in 2007. Dea Trier Mørch is the best-remembered artist from the collective. The one behind

How is Red Mother's art experienced today? For some, probably as deeply naive. It is true that the era of the hippie movement and the youth rebellion has a tinge of innocence. It comes from the belief that the world can be changed if you want to do it and that it might be useful to appeal to people's common sense, conscience—and humor. There is probably some romantic touch to working collectively with art. Especially for a generation that grew up with currency speculators and nouveau riche dot-com millionaires as heroes. . . . We believe that the awareness of being able to alter social conditions and the energy to organize and be active was often shaped and mediated by art, rather than as a result of a deep analysis of society. An art that comments on the overall development as well

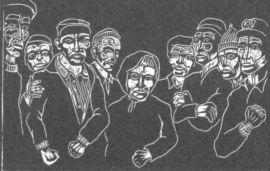

NACIONALIZACION DEL COBRE

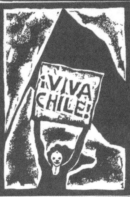

¡VIVA CHILE!

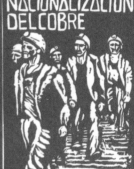

REFORMA AGRARIA

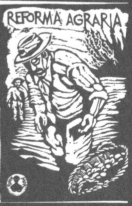

KURASJE Nº 5 : CHILE
ØSTERVOLDG. 8, 1350 KBH. K. GIRO: 166o44

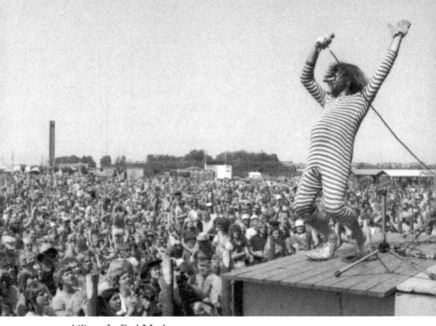

as mobilizes. In Red Mother, we found inspiration in the art and politics of the 1930s. Similarly, a new generation of critical activists might find inspiration in the time before yuppies and stockbrokers. There is still a lot of good energy in what many would probably call naivety and utopian dreaming. And we believe that time is again clamoring for satire and solidarity and for action.

Time is indeed again clamoring for some kind of action. Action against passivity, catastrophe, and the somnambulistic stumble through the landscapes of the new flexible, bio-political capitalism that has evolved since the 1960s and 1970s. Besides being an effective example of DIY ethics, the collective's history illustrates experiences of working in a politically oriented cultural collective that wants to intervene in, expose, and subvert, the language and mechanisms of power with new ideas, new language, and new images. From this there may be lessons in what to avoid when the class struggle has become a semiotic war—how to criticize what is while informing about what was and could be.

In the course of its existence, Røde Mor discovered that to be part of the closed circuits of institutional art and mainstream museums meant maintaining and accepting the status quo. Instead, they took on the challenge of gaining greater visibility through a more DIY use of prints, posters, happenings, and music as a propaganda form. But increased visibility always carries certain risks. When one becomes visible, one becomes recognizable and can be pigeonholed to a specific identity. One of the ways power operates today is in how we are pinned down bio-politically as subjects with a fixed identity. If the political project is one of questioning and exposing this power, it becomes a matter of avoiding full visibility— e.g., working anonymously or collectively—and keeping a foot and a half in the shadows, outside of formal institutions.

It is not about positing a certain identity in opposition to power, but rather the dismantling of the binary structure of power and identity itself. It becomes a question about avoiding fixed identities and remaining open to an indefinite field of different articulations of resistance. Otherwise, one's project will be recuperated, one will find oneself becoming a new institution

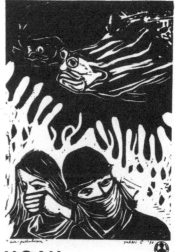

NOAH
Kompagnistræde 37°·8·
1208 K
Giro 160039; 10 kr for 6 numre

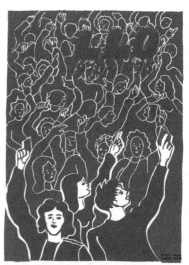

**KONGRES·25·27·APRIL·
HVIDOVRE·MEDBORGERHUS**

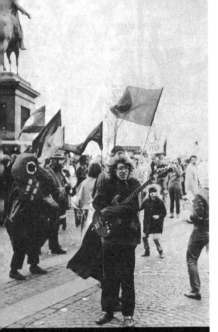

of power and thus harmless to the status quo. This is what happened to Røde Mor. They ended up an institutionalized circus with a graphic department and professional structures. When this started to restrict their possibilities, they shut down and redistributed their wealth and power through a support system for engaged arts and graphics. They were unsatisfied with their increasing role as the court jester.

Røde Mor believed that revolution could be culturally led, but they lost faith and became locked in an outdated identity based on the 1960s myth of a postscarcity society fed by the industrialization of agriculture and industry—a vision proved false by the economic crisis of the early 1970s. This changed the territory of resistance, but the collective still serves as a reminder that by sharing information and pooling resources, artists can generate new exit routes from everyday life under capitalism as well as actively change people's perspectives and values. Additionally, they show that simple methods of production and imagery drawn from

popular art and folk art are often as effective as the tools utilized by so-called High Art. In the sheer joy and abundance of their early years, it is possible to see the collective as a demand that capitalism's age-old promise be fulfilled in the here and now: a life free from the bridle of scarcity and the monotony of mundane labor, while rich in human solidarity and sensual, aesthetic expressivity. \mathbf{S}

Notes

1. All translations of titles, manifestos, etc. are by the author.
2. See http://www.leksikon.org/art.php?n=2193.

PM PM Press was founded at the end of 2007 by a small collection of folks with decades of publishing, media, and organizing experience. PM Press co-conspirators have published and distributed hundreds of books, pamphlets, CDs, and DVDs. Members of PM have founded enduring book fairs, spearheaded victorious tenant organizing campaigns, and worked closely with bookstores, academic conferences, and even rock bands to deliver political and challenging ideas to all walks of life. We're old enough to know what we're doing and young enough to know what's at stake.

We seek to create radical and stimulating fiction and non-fiction books, pamphlets, t-shirts, visual and audio materials to entertain, educate and inspire you. We aim to distribute these through every available channel with every available technology—whether that means you are seeing anarchist classics at our bookfair stalls; reading our latest vegan cookbook at the café; downloading geeky fiction e-books; or digging new music and timely videos from our website.

PM Press is always on the lookout for talented and skilled volunteers, artists, activists and writers to work with. If you have a great idea for a project or can contribute in some way, please get in touch.

PM PRESS
PO Box 23912
Oakland CA 94623
510-658-3906
www.pmpress.org